Happy 80th

IMAGES
of America
ORONO

With love,

Kathleen + Rolf

April 28, 2009

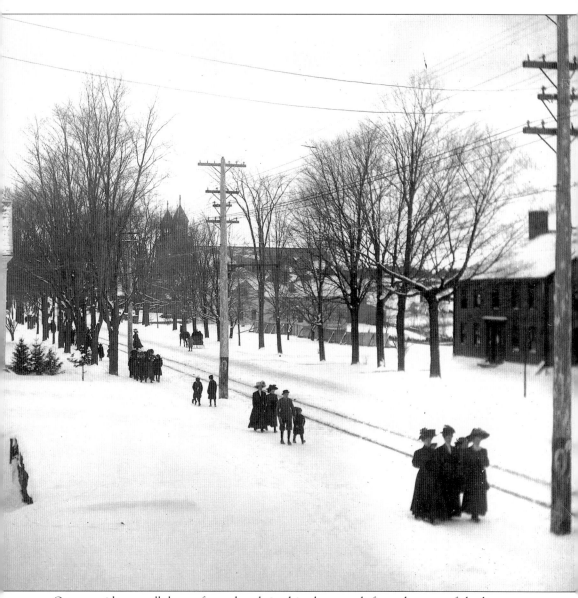

Orono residents walk home from church in this photograph from the turn of the last century. The styles of the Sunday-best clothes help date this picture, along with the empty foundation on the far left, which was likely the site of the Orono House, a hotel that burned in the early 1900s.

IMAGES
of America
ORONO

Scott D. Peterson

ARCADIA

Copyright © 2004 by Scott D. Peterson
ISBN 0-7385-1344-X

First published 2004

Published by Arcadia Publishing,
an imprint of Tempus Publishing Inc.
Portsmouth NH, Charleston SC, Chicago,
San Francisco

Printed in Great Britain

Library of Congress Catalog Card Number: 2004101331

For all general information, contact Arcadia Publishing:
Telephone 843-853-2070
Fax 843-853-0044
E-mail sales@arcadiapublishing.com

For customer service and orders:
Toll-free 1-888-313-2665

Visit us on the Internet at www.arcadiapublishing.com

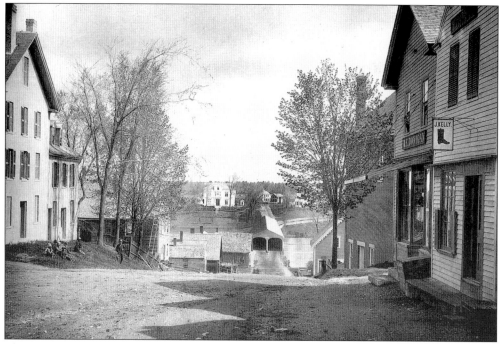

This picture shows the top of Ferry Hill in the 1890s. Other landmarks include the toll bridge across the Stillwater River and the mansion of Col. Ebenezer Webster on the other side of the bridge.

# CONTENTS

Introduction                                                            7

Acknowledgments                                                         8

1.    Meet Me in Monument Square                                        9

2.    Why Not Trade in Town?                                           25

3.    20,000,000 Board Feet                                            41

4.    Equal to the Advantages of the Best Academies                   57

5.    To Speed the Plow and Fatten the Crop                           75

6.    Undefeated and Unscored Upon                                     89

7.    Now Showing: The Nationally Known
      Kid's Band of Orono                                             111

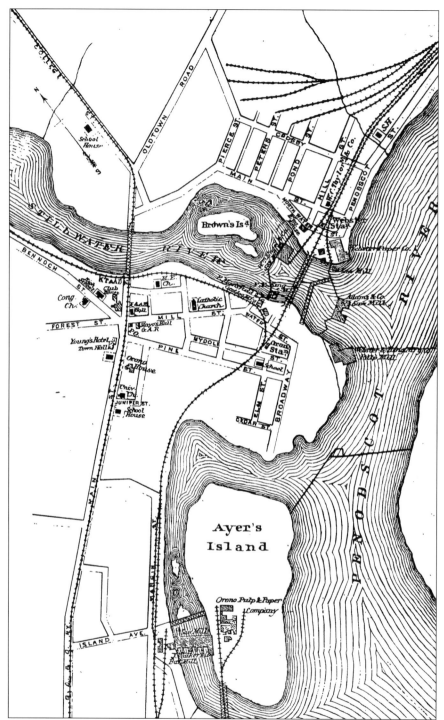

This map of Orono dates from sometime between 1874 (when the first town hall was built) and the early 1890s (when the Webster pulp and paper mills at the mouth of the Stillwater were sold to International Paper). Note also that the high school is still located in the Bennoch Street School and the Catholic church is on Mill Street.

# INTRODUCTION

Jeremiah Coburn and Joshua Eayres first settled Orono in 1774 by making "great improvements" on their lands and building two dwelling houses, half a sawmill, and two roads, according to their petition to the colonial government of Massachusetts. These two settlers and their families left Orono during the Revolutionary War but returned to take advantage of the site's abundant source of waterpower along with its rich farmland. Whether its inhabitants came in search of fish, farmland, or a source of waterpower, Orono's name, people, and contributions have been a series of confluences.

The Penobscot Indian name for Marsh Island and the falls at the junction of the Stillwater and Penobscot Rivers was *Arumsumhungan*, which translates to "the place where alewives are found" and proves that people have been drawn to this spot since prehistoric times. The man for whom the town is named also represents a series of confluences. Joseph Orono, a chief of the Tarrantine (an early name for the Penobscot) tribe was sympathetic to the efforts of the American colonists in the Revolutionary War and was also an adherent to the Catholic religion, making him a unique blend of cultures from the start. Most reports give the color of his eyes as blue, and some accounts of his origins make him the son of a French nobleman and an Indian princess, while others have him being stolen away from a French settlement and being raised by the Tarrantines—only to choose to remain with the latter upon learning of his true heritage. Either way, the figure behind the town's name serves as a symbol of the coming together of American Indian and Anglo cultures.

The blending of cultures continued throughout the 19th century, when the Yankee settlers of the town—the Pages, the Websters, and the McPheters—were joined by French Canadian immigrants—the Cotas, the Leveilles, and the LaFrances. These two cultures worked in the same mills, operated businesses side-by-side, and sent their children to be educated in the same public schools. Together, these two cultures helped give Orono a unique flavor as town.

In the 1850s, Orono was the home of the world's largest sawmill and was a leader in producing lumber that was shipped out of Bangor to far-flung destinations. In 1865, the rough-and-tumble lumber town became the home of Maine's land grant university, which was charged with the task of educating the state's young men and women in the agricultural and mechanical arts to keep them from leaving for better opportunities in other states. Although the lumber and paper mills are no longer a part of Orono's landscape, the University of Maine continues its mission today with developments like composite wood technology that make the most of the state's resources and keep its residents here by creating new jobs.

I have attempted to capture some of this unique town's rich history in this book, selecting photographs that illustrate its development over the last 200 years, along with the people that helped make the town what it was—and is. Many of the photographs spoke to me because they contained stories that offered insight to the town, as well as life here in Maine (and by extension, small towns all over the country). If readers enjoy this book half as much as I have enjoyed putting it together, then I will be satisfied that my efforts have indeed been worthwhile.

# ACKNOWLEDGMENTS

For many of the facts and details in this book, I am indebted to the Orono historians who have gone before me: Dr. Doug Glanville, longtime president of the Orono Historical Society and author of *Old Orono Oddments*, which served as the backbone of this project, and Dr. David Smith, whose book on the University of Maine, *The First Century*, was invaluable. I also used the address of Gov. Israel Washburn published in *Orono Centennial* and the unpublished history of Hannah Rogers. I would also like to thank the Orono Historical Society for its support, especially Alice and Charlie Smith, June Anderson, Sherman Hasbrouck, Helen King, and Don and Ann Pilcher. Several Orono residents were also helpful: Mike Ambrose, Jimmy Cowan, Bruce Farnsworth, Phil Hachey of the American Legion post, Joe Haverlock, Robert Milheron, Gloryanne Prue, Capt. Henry Vaughn of the Orono Fire Department, and Susan Young.

*One*

# MEET ME IN MONUMENT SQUARE

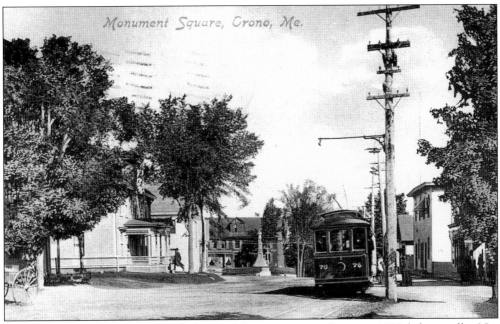

This postcard offers a glimpse at the heart of Orono sometime between 1902 (when trolley No. 76 was purchased) and 1910 (the date of the postmark on the back). The Civil War statue, hence the name Monument Square, is facing to the south, and elm trees form a canopy over the river town's dirt streets, both sights that are long gone but not forgotten.

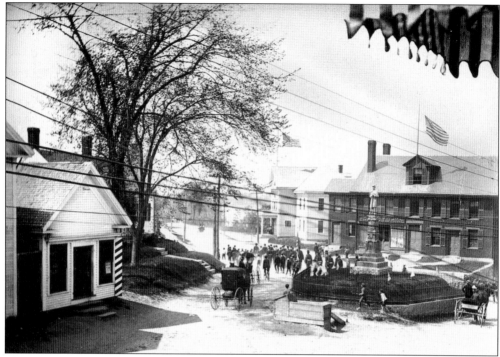

The square saw all sorts of activity, including funeral processions on their way out to Riverside Cemetery. Note the flags flying at half-mast on the Katahdn Building and the Bennoch Street School. Other key details to the period of this photograph include the watering trough at the foot of the monument and the iron fence around it.

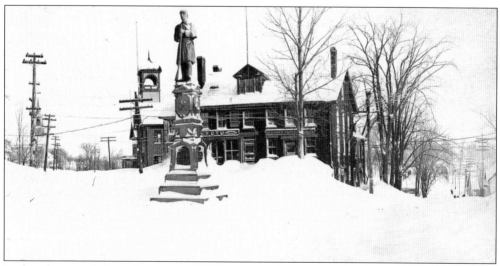

In this photograph from the winter of 1921, the cupola on top of the Central Fire Station, built c. 1910, is visible to the left of the monument. The Women's Christian Temperance Union library was housed in the Katahdn building, and it was probably open that day despite the snow. The new steel bridge is visible at the foot of Ferry Hill in the lower right.

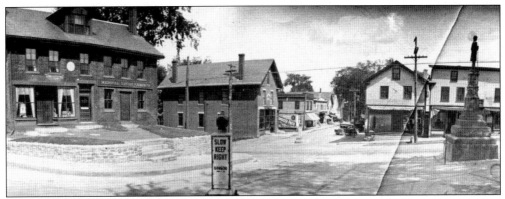

As Orono entered the Depression in the early 1930s, the evolution of Monument Square continued. Here, the mound and the watering tank are gone, making room for motor traffic. The Katahdn building is home to Merrill Trust and the telephone company. Upper Mill Street is visible in the center of the picture.

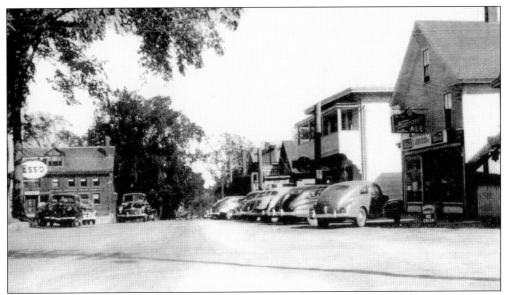

Although the Civil War statue is missing from this 1940s postcard (at this point it was residing next to the town hall just out of the picture to the left), from the American Art Postcard Company, this part of Orono was—and still is—known as Monument Square. Note the parking on Main Street and the absence of the trolley tracks, indicating yet another change in the downtown.

11

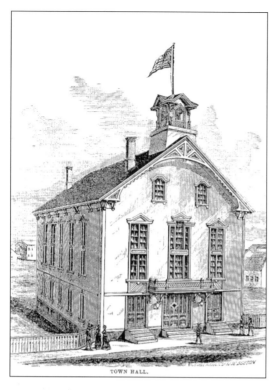

TOWN HALL.

Here is Orono's first hall, dedicated in 1874 with a ceremony that included a speech by Gov. Israel Washburn, who grew up in Orono. The first town hall burned in 1891. A second three-story building was built in 1891 and burned in 1904. In 1885, residents at the annual town meeting voted to spend $250 to put a bell in the tower, but it was not able to save the building either time.

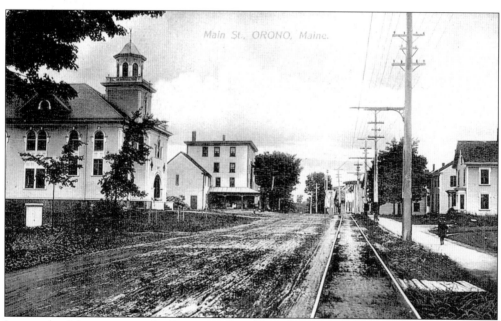

Just south of the square are the University Inn (the square three-story building) and the town hall. The inn got its name from serving as the residence for faculty at the university. In the 1930s, it became known as South Hall, when it served as a cooperative dorm for women. According to Maud Webster's history of Orono, the building was originally constructed in 1828 and was known as the Stillwater Exchange.

12

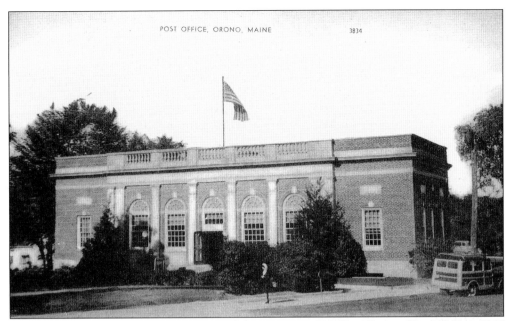

POST OFFICE, ORONO, MAINE          3834

Orono's present post office became a part of the square in 1933. For 15 years (from 1861 to 1865 and 1869 to 1879), Samuel Libby, an apothecary, served as the town's postmaster in the brick building at the corner of Main and Mill. According to Hannah Rogers, Samuel Freese ran the post office in the store at the corner of Main and Pine from 1856 to 1860.

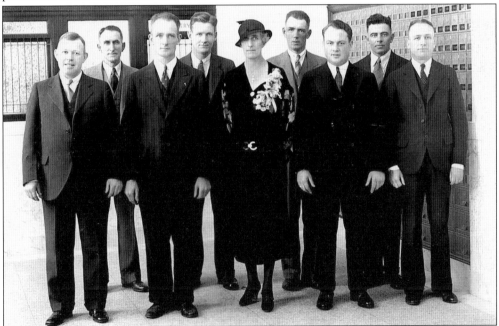

In the early 1930s, postal patrons were greeted by the staff members seen here. They are, from left to right, as follows: (front row) Stanley Cowan, Byron Smith, Louise Harding Ring (postmistress), Leroy Scott, and Bert McKenzie; (back row) George Ambrose, Roland Willett, Leslie Smith, and Tom McGinn. In 1934, Harding married Hal Ring, who worked just across the square as a clerk in Nichol's Pharmacy.

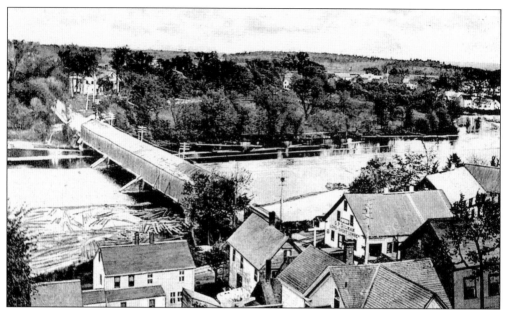

It is just a short walk from Monument Square to the base of Ferry Hill, where a bridge has connected the town to March Island since the early 1830s. The first structure was a double-barreled covered toll bridge that cost 2¢ to cross. At the far end of the bridge is the part of Orono known as the Webster side due to the elegant residences of the Webster family.

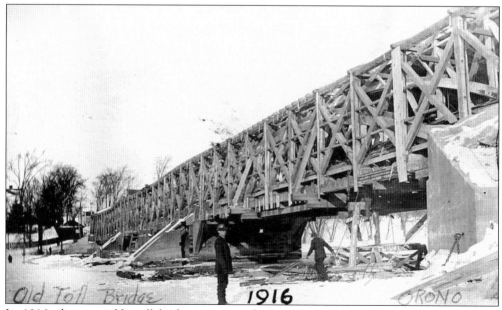

In 1916, the venerable toll bridge was torn down to make way for a new steel structure. According to the message on the back of a postcard from that era, people driving cars had to park them at the foot of Ferry Hill and walk across on the ice, which seems to be the case for the people pictured in this postcard.

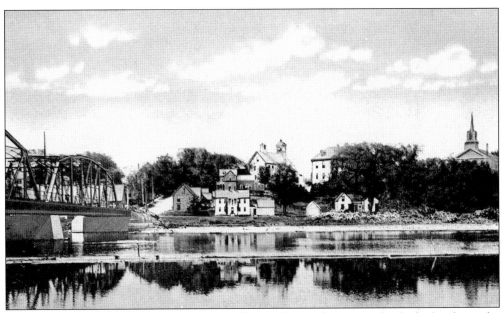

The second Stillwater River bridge is pictured on the left in this postcard, which also shows the Central Fire Station (with the cupola), the Bennoch Road School, and the Congregational church. The steel bridge was an Orono landmark from 1916 until 1950.

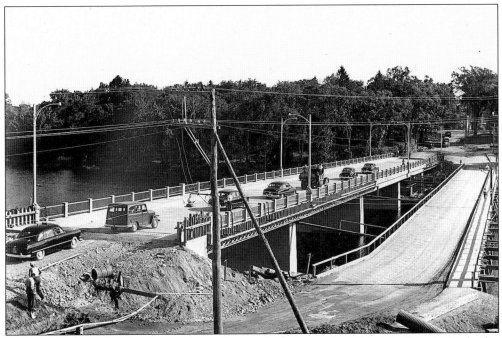

This 1950 view shows the construction of a new bridge over the Stillwater River. This bridge was in service until the early 1990s, when it was replaced with a similar structure. Note the temporary bridge on the downriver side; no one had to get out and walk across the ice this time.

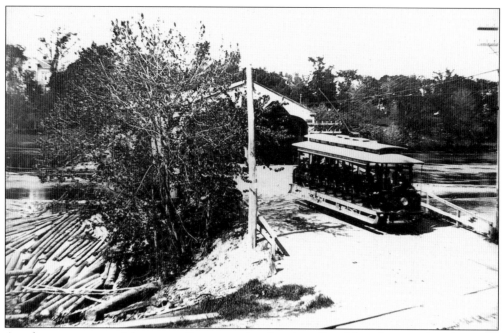

Another way to get to Monument Square was by electric trolley. This photograph, taken prior to 1916, shows the trolley as it is leaving the covered toll bridge. Trolley service from the Bangor, Orono, and Old Town Railroad Company started in the summer of 1895, with a car passing through town every 30 minutes.

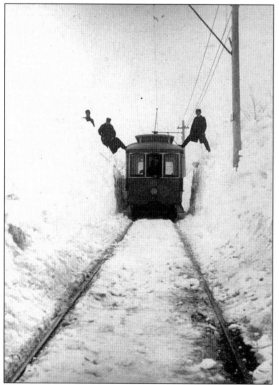

Anyone who doubts what winters were like in the good old days needs to have a look at this photograph from 1905, when trolley passengers on Main Street were afforded a lovely view of snowbanks. The view was probably much the same as the cars passed by the university on College Avenue on the way to Stillwater Corner, Old Town, and Great Works.

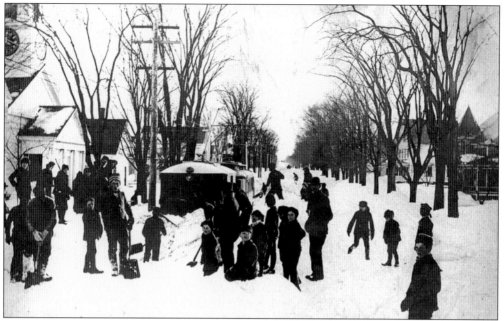

Orono was enjoying another good old-fashioned winter in 1920, when the trolley was snowbound on Main Street for six days. Here, local residents of all ages turn out with shovels to help free the stranded car. In 1853, the town voted to contribute $200 toward the purchase of a clock to be placed in the belfry of the Universalist church (on the left) if $400 could be raised from other sources. It was, and the clock still works today.

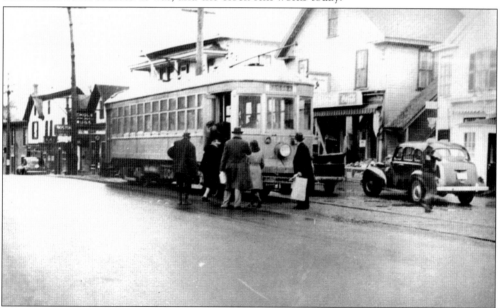

Making its final run from Great Works to Bangor, the trolley stops in front of Annie Gee's one last time in March 1940. An old story places a trolley on College Avenue just as university students successfully fired one of the spiked cannons overlooking the Stillwater. The concussion from the blast shattered some windows, but no passengers were hurt. For their part, the cannons were filled with cement.

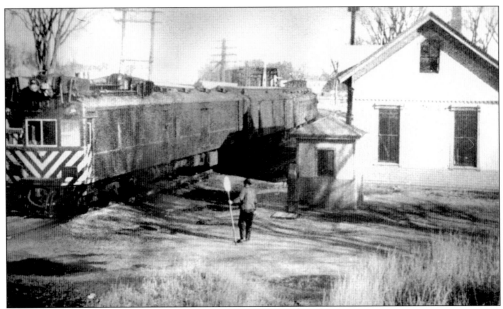

Another way to reach Monument Square was by passenger train. Pictured here is the first diesel engine arriving at the Maine Central Railroad station on Middle Street, *c.* 1927. The crossing attendant is probably "Tot Eye" Beaulieu. University students often arrived by train, only to be hustled out of the "Tough End," with its saloons and dance halls, as quickly as possible.

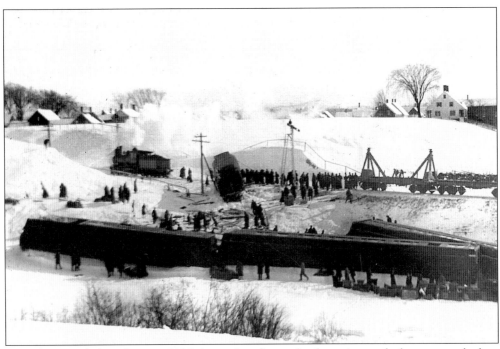

This photograph from January 1898 shows the aftermath of a train wreck that occurred when the passenger cars of the St. John Express left the rails on Frenchman's Curve, a section of track just south of the Orono station. A temporary hospital was established in the town hall, and several Orono residents helped rescue and care for the injured passengers.

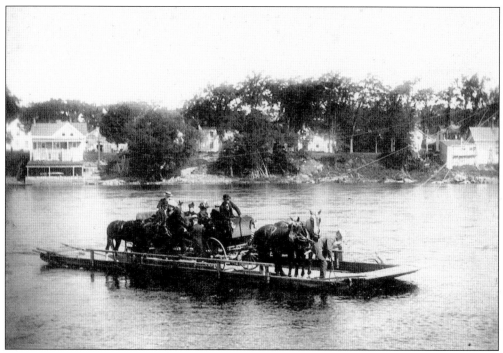

Yet another way to reach Monument Square was by the ferry that linked Orono to the town of Bradley, just across the Penobscot River. Not to be confused with a much earlier ferry that operated from Ferry Hill, this ferry ran from a landing on Penobscot Street on the Webster side (pictured in the upper left-hand portion of this photograph).

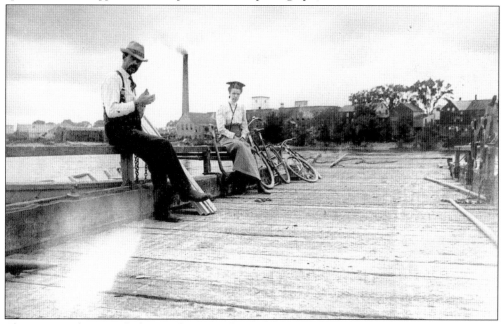

This c. 1900 photograph shows Ulysses Walker, the operator of the ferry, and a young passenger who appears to be on a bike ride (presumably with the photographer). The smokestack in the background is part of the Webster (or International Paper) mill.

One Orono landmark that trolley passengers on their way to Monument Square missed was the original McPheters farm, which was located on Main Street near Johnny Mac Brook. This farm, pictured here in 1853, was the home of Archibald Springer McPheters, who fought in the Civil War, and Henry McPheters, who, along with his brother, built dozens of houses in Orono, many of which are still standing.

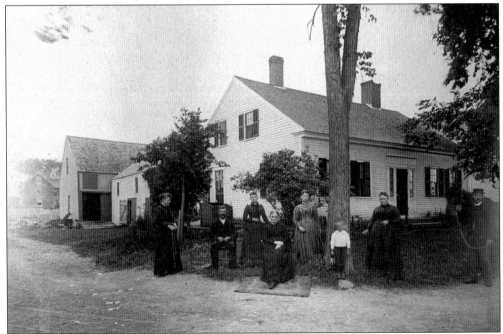

The house pictured in this photograph was built by William Coburn in 1780, making it the oldest house in Orono. William was the eldest son of Jeremiah Coburn, one of the town's original founders, and served in the Revolutionary War, according to Governor Washburn's 1874 centennial address.

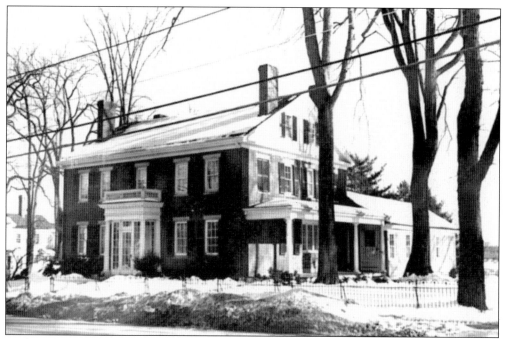

Nathaniel Treat's house, with its distinctive brick exterior, is another Main Street landmark in Orono. Treat served as a selectman for the town in 1835 and was also the president of the town's first bank, the Stillwater Canal Bank, from 1835 until it closed in 1842. The house was built in the early 1830s from locally made brick.

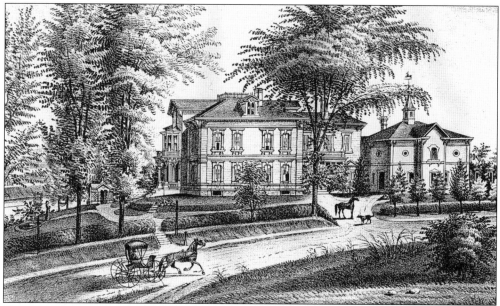

Ebenezer Webster, local lumberman and veteran of the Battle of Hampden in 1814, built this mansion overlooking the Stillwater River in 1827. After Webster's death in 1855, it was passed on to his son, Paul. During World War II, it was a cooperative dorm for coeds at the University of Maine after South Hall was torn down in the late 1930s. The University Motor Inn now occupies the site.

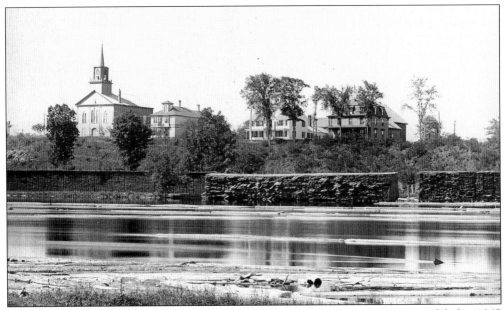

Orono's Congregational church was built in 1833. The one-story structure was remodeled in 1867 to include a vestry on the first floor and a steeple. In 1918, the church joined forces with the Universalist church to become the United Parish. The building (minus its steeple) was the site of the local public library until 1961 and now serves as the Keith Anderson Community Center.

Orono's Methodist church was also originally constructed in 1833, then remodeled and rededicated in 1867. Sometime later, the one-story building was raised so that a vestry and parlors could be built under the sanctuary. Early on, the Congregational and Methodist churches seemed to be in competition with one another in their construction projects.

The present St. Mary's Church building was constructed in 1905, making it the youngest of Orono's churches. The original church had been housed in the wooden building on Mill Street. According to Dr. Glanville's book, Fr. John Harrington, the parish priest at the time of the construction, was blessed with a gift of $2,500 from an anonymous donor to buy and ship the red granite required to complete the building.

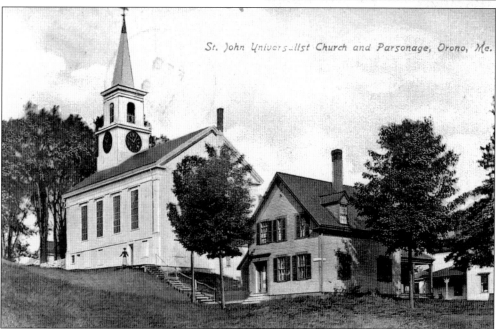

St. John Universalist Church and Parsonage, Orono, Me.

The first services were held in the Universalist church during December 1844. In the 1840s and 1850s, Orono's annual town meeting was held in the church vestry, which was known as Dean's Hall after the Scottish immigrant who finished building it. In 1941, the building became the home of the Church of Universal Fellowship.

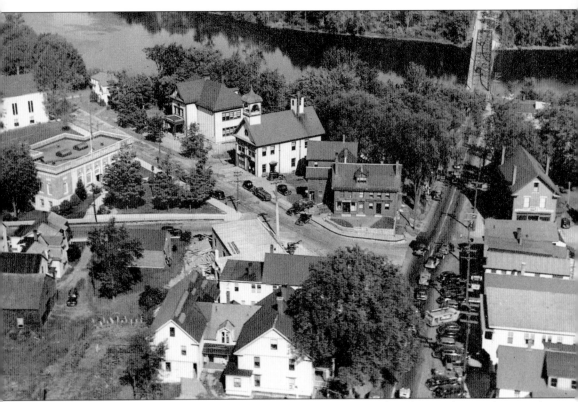

Even without the Civil War statue, Monument Square was the place to be, as this aerial photograph from the 1940s illustrates. The Congregational church (seen in the upper left, already missing its steeple), the post office, and the Katahdn Building are the only landmarks that remain from the original square. The white frame building hidden by the trees in the foreground was Capt. David Reed's house. This structure was the site of Orono's first tavern, as well as its first town meeting, on April 7, 1806. That building, which was a pizza place in its final incarnation, is gone now, along with the Central Fire Station, which burned in 1963, and the Bennoch Road School, which served as the town's first high school in the 1800s and then became the grammar school so fondly remembered by many longtime Orono residents.

*Two*

# WHY NOT TRADE
# IN TOWN?

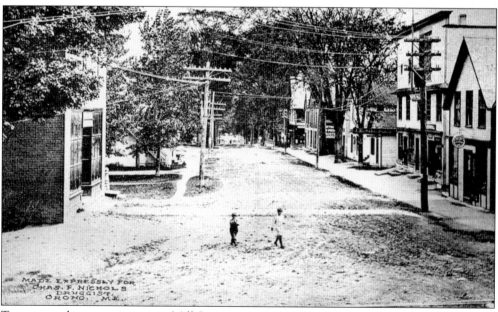

Two young shoppers cross upper Mill Street *c.* 1900 in a photograph taken from the foot of the Civil War statue in Monument Square. Note the trolley tracks in the foreground, the post office building made of local brick (left), and the overarching elm trees farther down the street.

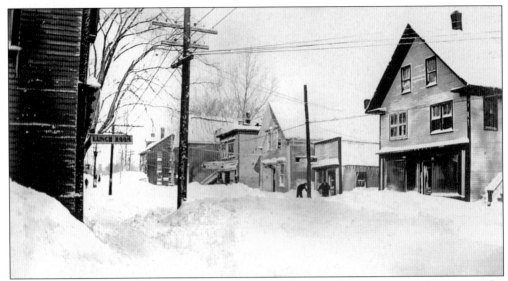

Taken during the winter of 1920, this photograph looks up Mill Street toward the square. The Katahdn Building is just to the right of the lunch room sign. Next comes the old post office (with the Masonic hall upstairs), then Myers' Grocery. The small building with the people shoveling out front was a tailor's shop. The store on the far right was originally built by Charles Gould in 1831 and is now occupied by a specialty foods store and a gift shop.

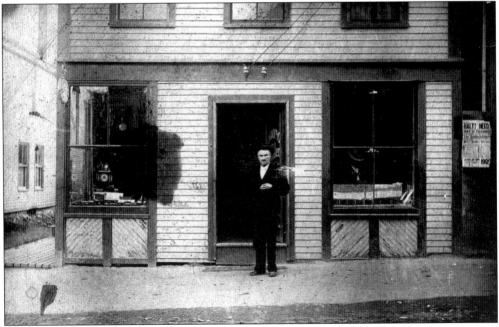

Before he moved his jewelry store to the square, Euger Leveille did business on upper Mill Street. According to Dr. Glanville, he was a member of the Ancient Order of United Workman in 1910. He also attempted to raise subscriptions for the town to buy a sprinkler for its dirt roads in 1908.

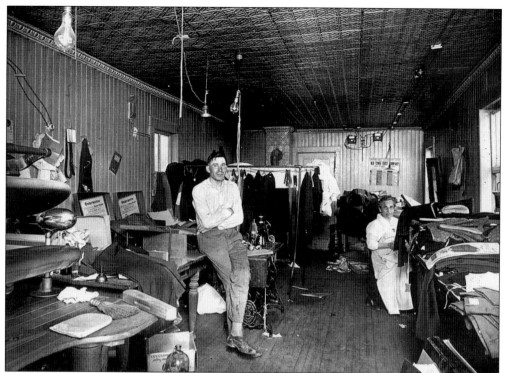

Ben and Sophie Hillson operated Hillson's Cleaners on upper Mill Street in the 1940s and 1950s. The business was located in the long narrow building that housed the tailor's shop (see the top of page 26). Today, that same building is the home of a sub shop.

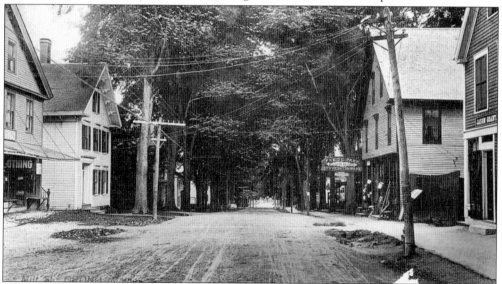

This postcard shows another view of the elms that once lined Mill Street. On the right is Jason Grant's candy store. Behind the fence, between it and Park's hardware store, was an icehouse. On the left side of the street is Leveille's clothing store, owned by Euger Leveille's brother Alex. He sold custom and ready-made clothing, along with "Boots and Shoes, Hats and Caps, Furnishing, Etc."

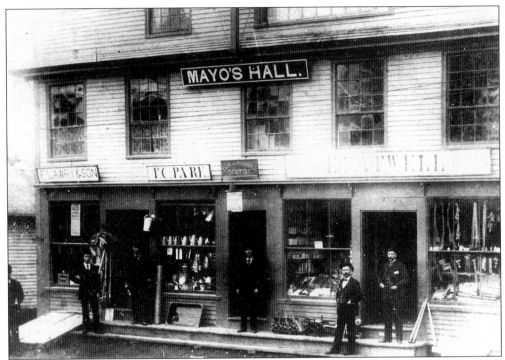

Here is downtown Orono as it appeared in 1892. Fred Park (standing in the first doorway from the left) opened his own hardware business after his old boss could not afford to employ him anymore. Some 111 years later, the local hardware store still bears his name, although the business is housed in a different Mill Street building. Upstairs, Mayo's Hall served as the meeting place for local fraternal or social organizations.

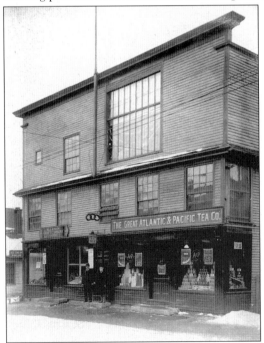

This photograph shows the continued evolution of the building at 7, 9, and 11 Mill Street. Fred Park has already moved his business to its current location farther down the street. In its place is Ganing's Confectionary. E. F. Atwell, a local merchant and the elected fence viewer (an old-time position overseeing fence disputes), has given way for the arrival of the local A & P.

This close-up of the same building affords us a look at some of the advertising. The thermometer to the right of the door and the chewing gum signs hanging in both windows are advertisements for Coca Cola products. The "K of P" sign in the upper right refers to Knight of Pythias, a fraternal organization that met in the hall upstairs in the early 1900s.

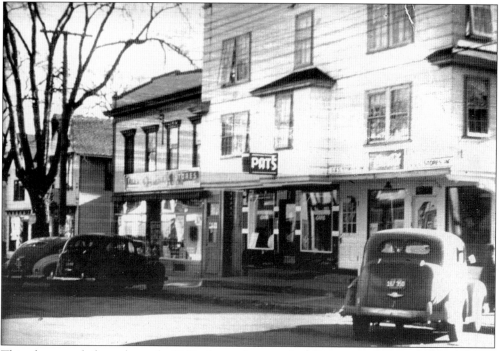

This photograph from the early 1940s shows the same building as most Orono residents know it—the home of Pat's Pizza. Pat Farnsworth opened his café in 1931. Pat's did not start selling pizzas until the 1950s, and now it is one of the most recognized franchises in the state.

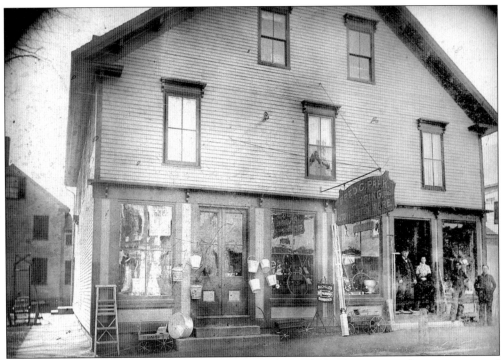

This 1902 photograph shows Fred C. Park's hardware and plumbing store after it was moved farther down Mill Street. Pictured in the doorway are Fred Park, Alice Averill, Bill Lugo, and Fred Harris. According to Dr. Glanville, Park's father was a skilled edge toolmaker who moved to Orono in 1872 and worked for Edward Mansfield at his cant dog factory.

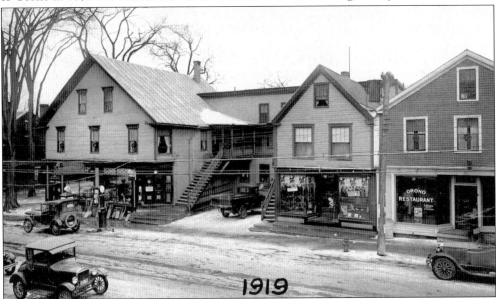

Fred Park bought Jason Grant's candy store and then connected the two buildings to open Park's variety store, as this 1919 photograph illustrates. Grant was a Civil War veteran who was shot through the lungs but lived to the age of 89. To the right is the Orono Restaurant, which had been the Parady & Lugo Hardware Store in 1912.

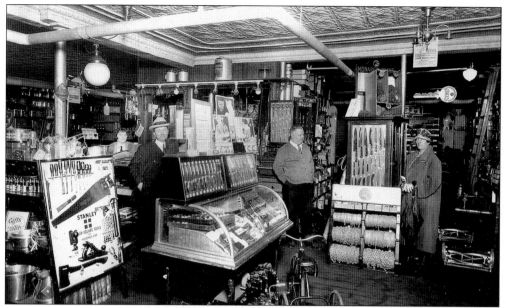

This is the interior of Park's hardware in August 1924 (current Orono residents will note just how little it has changed over the years). Wilbur Park, Fred's son, is pictured in the center of the photograph. He operated the business until his retirement and then sold it to Linwood White Sr., who elected to keep the original name. The family business tradition now continues under the direction of Linwood White Jr.

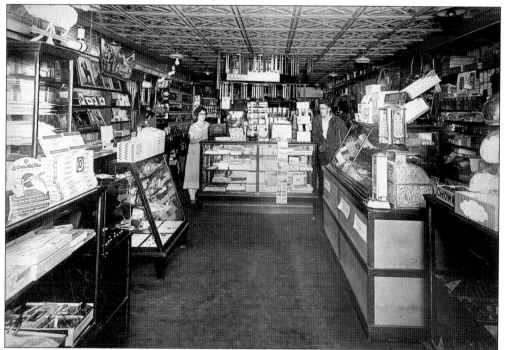

Here is what the interior of Park's variety store looked like at about the same time as the above photograph was taken. Called "the biggest little store in town," it was a gift shop offering a wide array of novelties, cut glass, fancy china, as well as a full line of stationery and greeting cards.

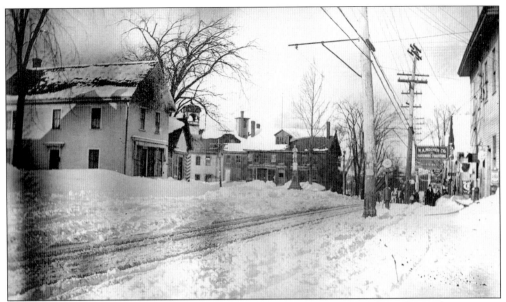

Neither heavy snow nor freezing cold can keep these Orono citizens from doing their part to support local merchants during the winter of 1920. The W. A. Mosher Company (on the right) offered "the best of furniture, whether it be in sets or separate pieces, for living-room, dining-room, chamber or den," and it offered them "in the most approved style." It also offered a full line of wallpapers and hardware.

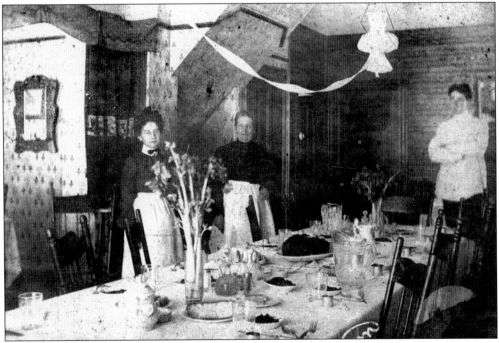

Patrons of Abbott's Dining Room on Main Street would have sat down to Thanksgiving dinner at this table in 1901. From right to left are Mildred George, Mrs. Morrison (the cook), and Howard A. Smith (the proprietor). This establishment served meals to visitors and travelers staying at the University Inn and the Orono House, two local hotels.

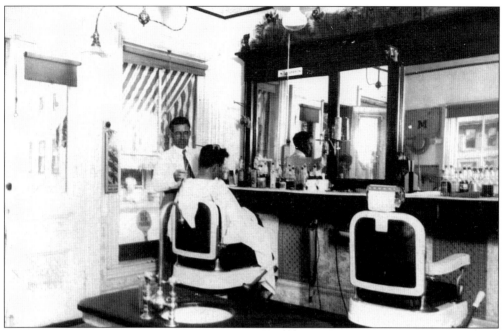

Orono barber Murray D. Milheron pauses for a photo opportunity during the 1930s. At one time, Milheron owned shops on three sides of the square. Before safety razors were invented, many men let barbers take care of their shaving duties and kept personal mugs at their favorite shops.

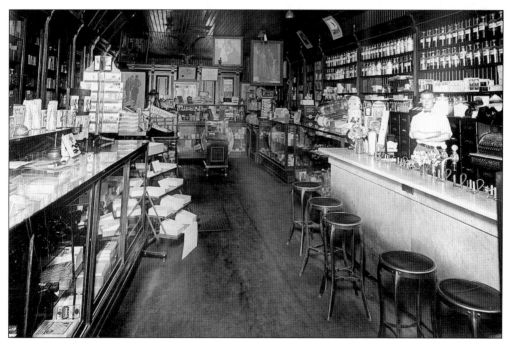

Elwood Round waits for the next batch of thirsty customers at the soda fountain of Nichols Pharmacy in this picture from 1923. Local legend had older generations slipping in for a banana split or an ice-cream soda while the kids were in school. The pharmacy was located at 34 Main Street and opened in 1894. In 1929, the store filled its 100,000th new prescription.

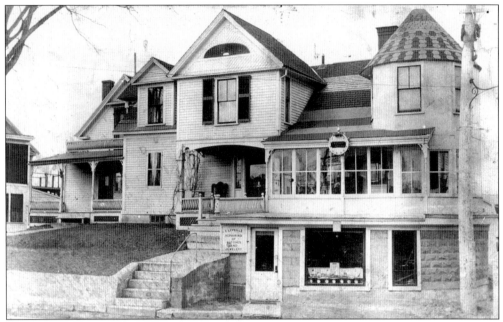

This photograph shows Euger Leveille's jewelry shop in its second location, on the square, just off Main Street, where he started his 22nd year of doing business in 1924. In addition to carrying "pendants, rings, earrings, and many alluring things to catch the feminine eye," Leveille made and repaired watches. To catch the masculine eye, he sold guns and ammunition as well.

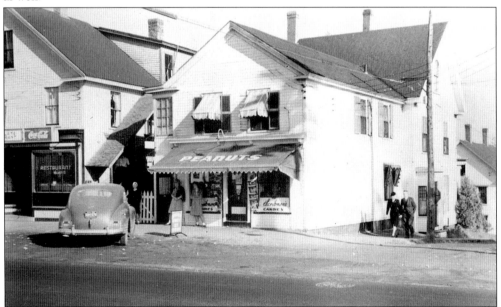

Here are some loyal locals buying their Sunday *New York Times* or a bag of fresh-roasted peanuts at Scribbie's. The building on the corner of Main and Pine has been part of Orono's business community since the mid-1850s. Until the 1960s, it was owned and operated by successive members of the McPheters clan. If those walls could talk, they would surely have a number of insightful things to say about Orono over the last 150 years.

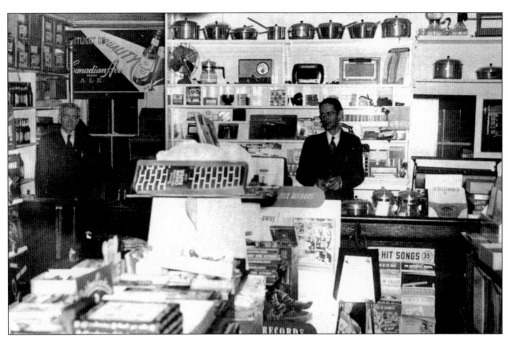

Orono shoppers could find everything from Canadian Ace ale to jewelry and their favorite music at Gerry's variety store on Main Street. When he opened his business in the years after World War II, Gerald Milheron (pictured here with his father, Murray) sold as many classical 78s to veterans returning from Europe as he could stock. Orono residents could also have their radios repaired at the store.

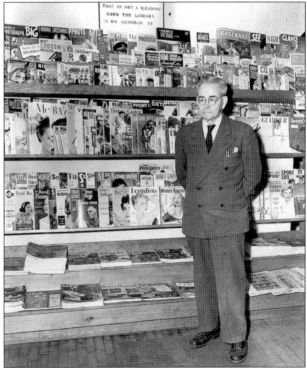

In this photograph from April 1952 (which was dated by Robert Milheron using the *Life* magazine on the lower left), Murray Milheron appears to be enforcing the sign over the magazine rack at Gerry's. According to his grandson, some of the store's clientele would read at the rack for hours on end without purchasing a publication—some of them going so far as to insert page markers in the books.

35

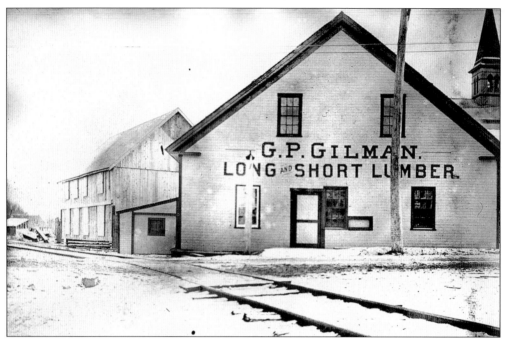

Ferry Hill, the section of Main Street between the square and the Stillwater River, is another part of Orono that has seen a good deal of change over the years. G. P. Gilman (who was married to Isabella S. M. Low of Bangor in 1864) sold long and short lumber out of this building at the base of Ferry Hill. The steeple of the Methodist church is in the upper right.

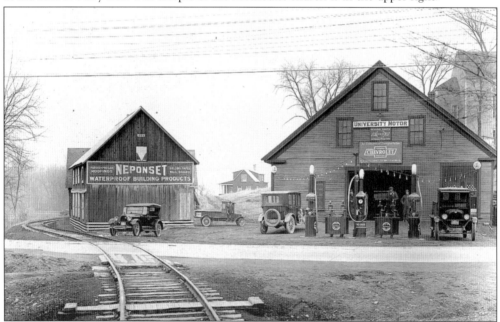

The presence of University Motor at the foot of Ferry Hill in this 1920 view attests to the arrival of the automobile age in Orono. The train tracks in the foreground belong to a railroad spur that once ran along the bank of the Stillwater River to a mill in the village of Stillwater. The warehouse on the left was owned by Fred Park of Park's hardware.

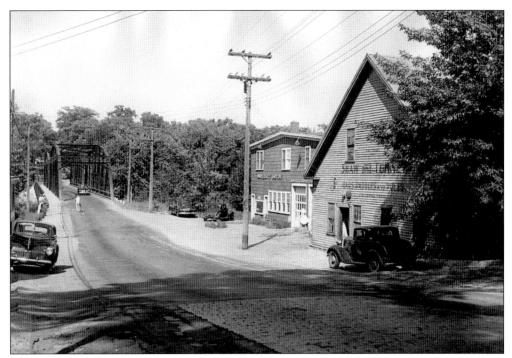

The surveyor at the near end of the bridge indicates that more change is in the offing, as he is helping to plan a new bridge over the Stillwater. Shaw & Tenney has been manufacturing oars, paddles, and poles since the 1870s. The business relocated to Water Street, where it continues to operate today.

This 1950 photograph illustrates how University Motor was raised during the process of improving the grade of Ferry Hill, making it less steep and less dangerous in icy weather. Also worthy of note is the Lubritorium, where one could presumably receive an oil change.

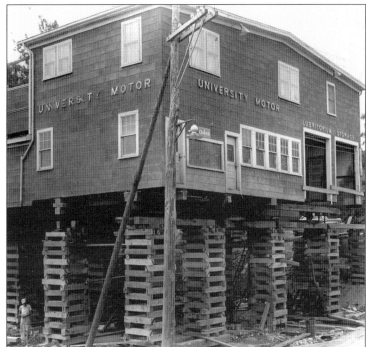

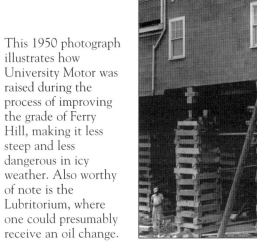

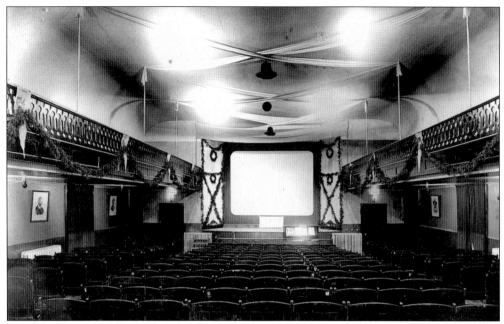

This photograph shows the interior of one of Orono's first theaters. It was opened in the early 1900s by Fred C. Park, who purchased the building at 74 Mill Street (the original site of St. Mary's Church). During World War I, moviegoers paid 10¢ and 20¢ for tickets, with ten percent of that price going toward a war tax.

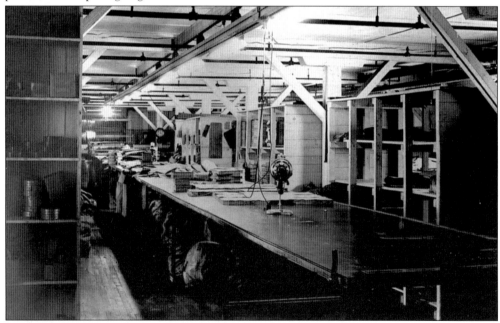

From church to theater to camp-accessory factory is the evolution of the building now occupied by Byers Manufacturing, as illustrated by this 1940s photograph of the cutting room. Byers took over the building in 1925. They remodeled the four-story building extensively and added a one-story office to the front. Between 40 and 50 people were employed there, with a stated promise that 95 percent of the employees would be local.

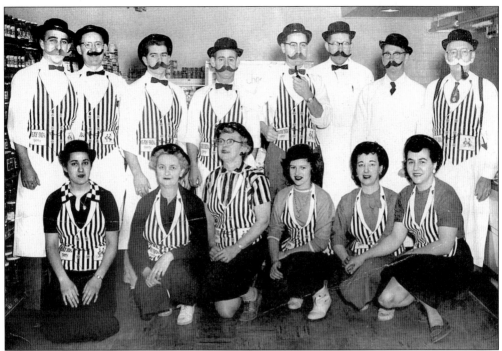

The employees of Sailor & Sons, a Mill Street grocery store that operated from 1957 to 1962, are looking sufficiently old-timey in this 1958 photograph. They are, from left to right, as follows: (front row) Margaret Casey, Thelma Nadeau, Rose Sullivan, Carol Cust, Milly Myers, and June Duplissa; (back row) Paul Prue, Tom Beaulieu, Bruce Pelletier, Vern Cust, Homer Beaulieu, Herb Cowan, Tom Casey, and Amos Conant.

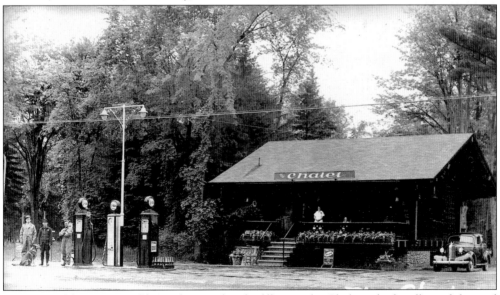

Motorists of the 1940s could get a hot meal and a fill-up at the Chalet, which still stands beyond the corner of Park Street and College Avenue. As the story goes, it was originally purchased in Switzerland, then disassembled and brought to Orono to serve as a playhouse for the Webster children. All of the logs are said to have a number carved into them to facilitate assembly.

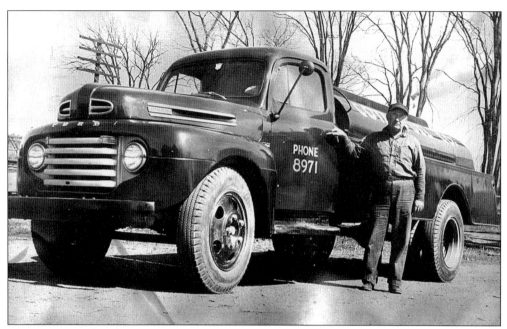

Leo Cota poses beside one of trucks from the Cota Oil Company fleet. Before becoming the proprietor of this well-known local business, Cota was a star third baseman for the Orono Orioles and the Penobscot Chemical Fiber Athletic Association (just upriver at Great Works). He worked as a stationmaster for the Maine Central Railroad before starting his own business.

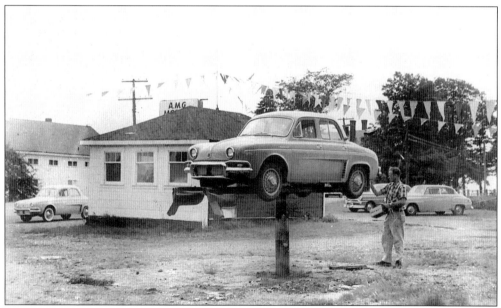

Here is a rare photograph from the short-lived A.M.G. Motors dealership, which was located across from the Penobscot Country Club south of town. Llewellyn Michaud, Gerald Milheron, and Jim Garrity formed a partnership to import Renault cars from France. The business was opened in the mid-1950s but never caught on in Orono and closed soon after.

# *Three*

# 20,000,000 BOARD FEET

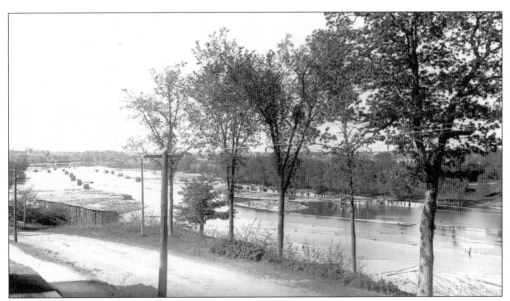

This picture, taken in the late 1800s, shows how the Stillwater served as the main artery for Orono's industrial might. The boom ties (some of which still exist more than 100 years later) dotting the river helped keep the logs sorted for their various destinations, which included the Basin Mills, the Engel sawmill, and International Paper.

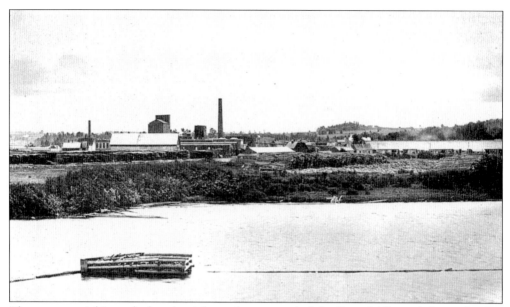

The raw material is stacked to the right in this postcard of the Basin Mills, and the cut lumber is to the left, soon to be transported to Bangor and then shipped out of New England. The Basin was home to three types of mills: a box mill and sawmills that were built on the channel between Ayers Island and Island Avenue, and Orono Pulp and Paper, which occupied the island itself.

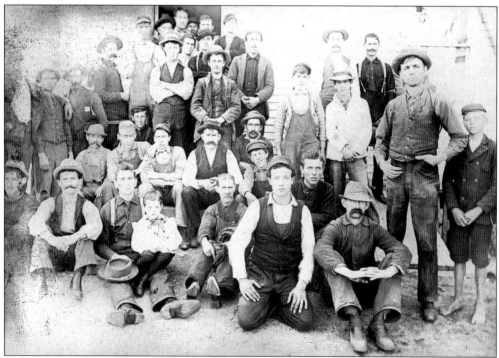

Unidentified mill workers pose for this *c.* 1900 photograph. According to Dr. Doug Glanville's book, *Old Orono Oddments*, an 1850 survey listed the capacity of the Basin sawmills at 20 million feet of lumber, 2 million shingles, 6 million laths, and 800,000 clapboards.

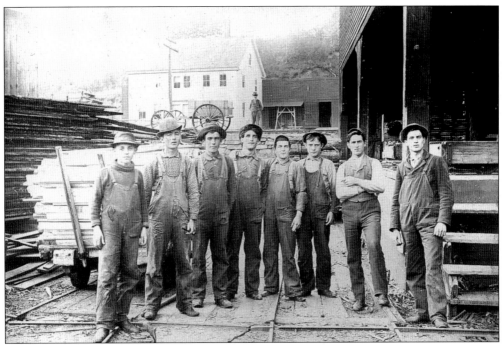

Members of the sawmill crew at the Basin Mills pose here. The precarious location of the box mill and sawmills made them vulnerable to spring freshets. If it was not ice, then it was fire. Both mills were badly damaged by a conflagration in 1910 that was large enough to require assistance from the Bangor Fire Department, which brought up a steam-powered pumper engine by rail.

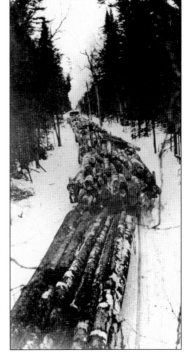

This postcard offers a graphic illustration of just how many logs were sawed to generate 20 million board feet of lumber. This load of 400 logs, pictured here as it is being brought out of the woods, translated to 36,000 feet of lumber. Doing the math, that comes out to over 222,000 logs for the lumber alone.

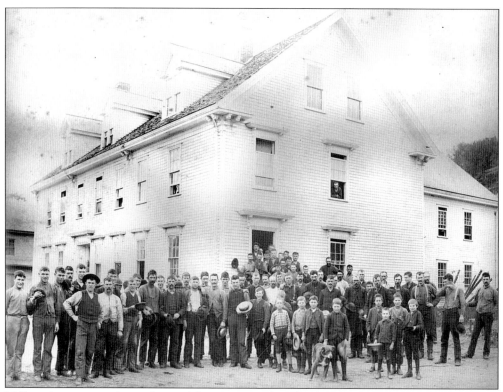

Mill workers pose in front of one of the two Basin boardinghouses. In 1885, a labor contractor named Thomas Viola came to Orono from Italy. He purchased a house from the Page family and operated it as a boardinghouse for other Italian immigrants. Many of these immigrants moved north to Millinocket to help build the Great Northern mill.

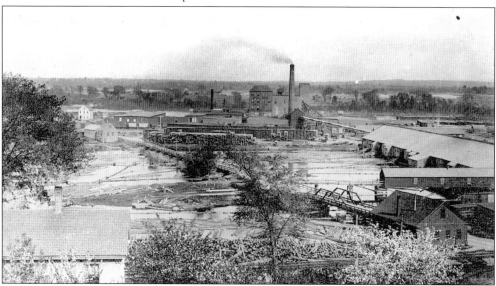

This postcard illustrates the Basin Mills complex. The sawmills are in the right-hand portion of the photograph. The pulp and paper mill is in the center of the island, situated around the smokestack. Margin Street and the Maine Central Railroad tracks are in the foreground.

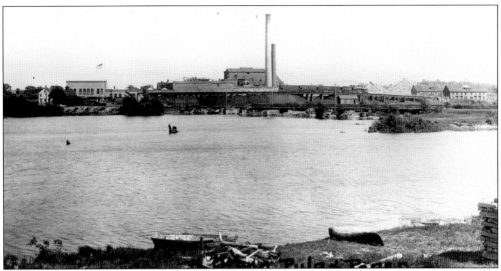

This postcard illustrates the rail spur that once ran onto Ayers Island. A steam engine and three coal cars are visible on the elevated tracks that allowed more direct access to the heart of the mill operation. The trestles for that rail spur are still visible today on the island.

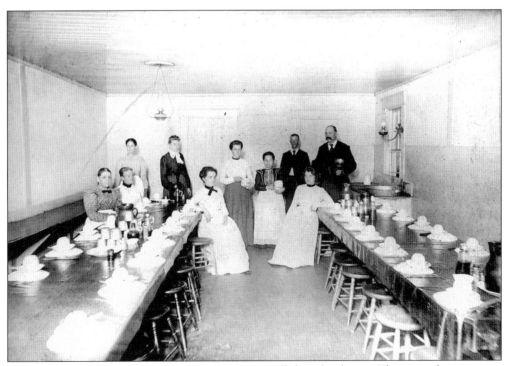

This photograph shows the wait staff at the Basin Mills boardinghouse. These people were some of the 100 local residents who depended on the operation of the mills for their livelihood, according to Dr. Glanville's book. In 1910, the total number of men employed at the Basin Mills was about 250.

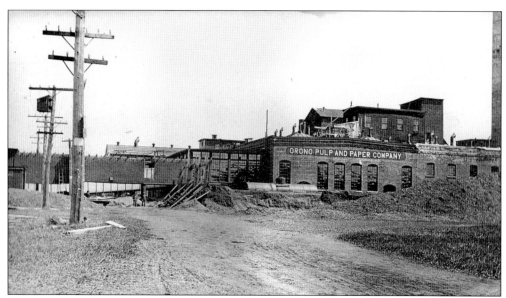

This postcard shows a close-up view of the mill building. In 1892, one of the pulp digesters exploded through the roof of the building and damaged the other two digesters when it fell back to earth. Two men attending the digester were killed, and a third worker died from his injures a month later. The blast did as much as $100,000 in damage to the building.

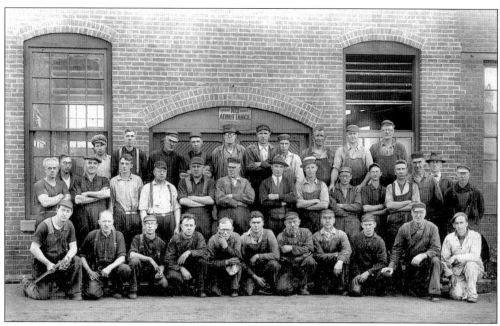

Some of the millwrights posing in front of Orono Pulp and Paper have been identified as follows: John Bapst King (first row, third from the right), Billy Richards (first row, fourth from the right), ? Melanson (first row, sixth from the right), ? Scott (second row, seventh from the right), Freeman Bamford (second row, eighth from the right), ? Kelley (second row, ninth from the right), ? Tracey (second row, tenth from right), Joe Beaulieu (third row, second from the right), and ? Stevens (third row, fifth from the right).

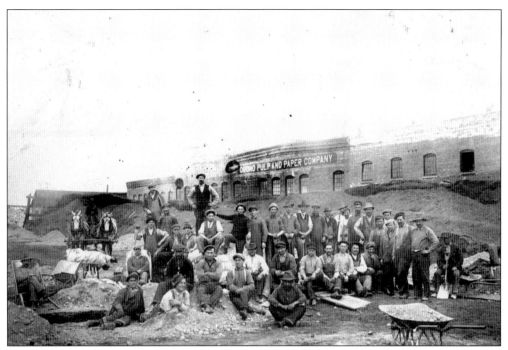

Italian immigrants pose in front of Orono Pulp and Paper c. 1900. They are thought to be responsible for some of the elaborate brickwork in the center of the Orono Pulp and Paper building complex. Italian immigrants also played a large role in the construction of Orono's first water system, which was completed in the early 1900s.

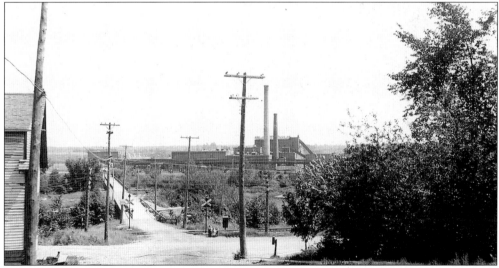

This August 1935 photograph shows the mill during a shutdown. Orono Pulp and Paper was founded in 1870. In the early 1890s, it operated briefly as Bangor Pulp and Paper before switching back to its original name. The pulp and paper mill reopened in 1938 under a different name before ceasing operations around the time of World War II.

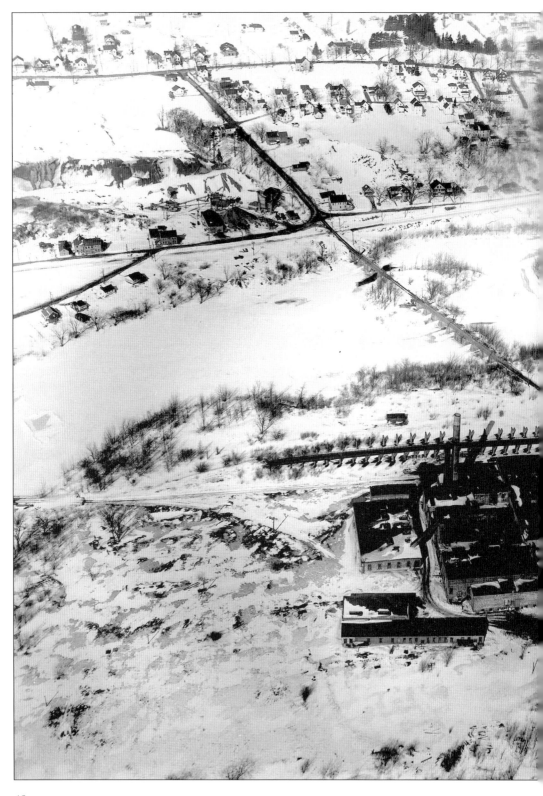

48

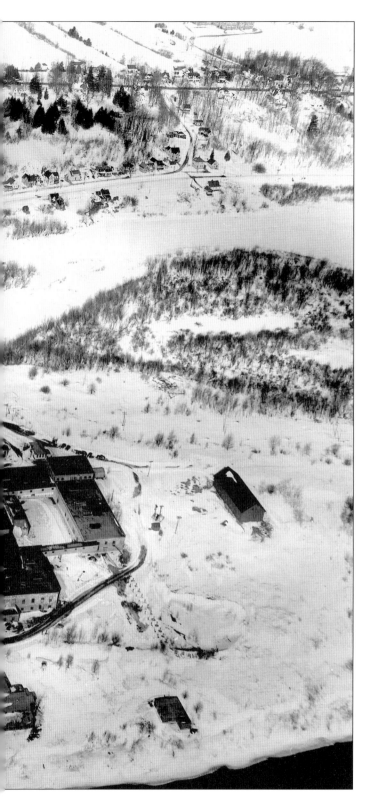

This aerial photograph shows Ayers Island some time after the new high school (in the upper right-hand corner) was built in 1939. Long gone are the box and sawmills that ran alongside the bridge connecting the island to the mainland. After Orono Pulp and Paper closed, the mill operated as a shoddy mill until it closed in 1996. During the 1960s, over 300 workers were employed by the mill. That number dropped to 125 in the 1980s. The island is now owned by George Markowsky, a computer science professor at the University of Maine and a local entrepreneur who hopes to continue the long history of industry on Ayers Island with light industrial businesses, as well as historical and cultural displays.

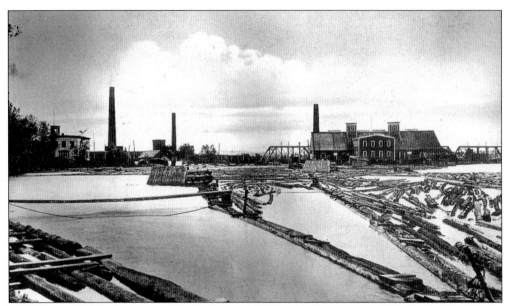

This postcard shows the industrial might once clustered at the junction of the Stillwater and Penobscot Rivers in Orono. The building with the two square towers is the Wing & Engel sawmill. Further downriver is the paper mill for International Paper (formerly known as Webster Pulp and Paper). The white building to the left is Monitor Hall, once the home of the fire engine for the Webster side.

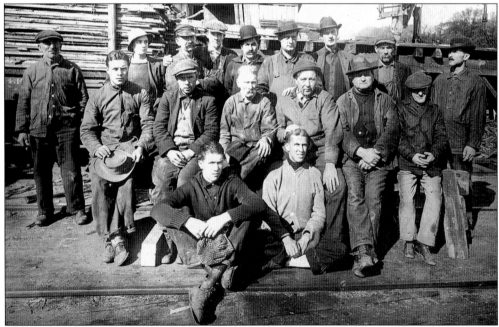

The Orono residents that have been identified from this photograph of the Wing & Engel sawmill crew include Harry King (second row, second from the right), Walter Avery (second row, third from the right), Freddy Parady (second row, fourth from the right), and Paul Babin (standing on the far right). The mill was located just above the present dam, and its foundations can be seen during periods of low water.

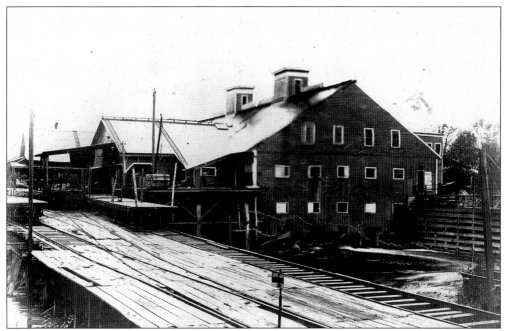

Here is the Engel mill from the Webster side. Note the rail trestle leading up to the mill. In 1886, Varney's *Gazetteer of Maine* gave the following totals for the mills on the Stillwater River: 22 single saws, 10 gang saws, 5 rotary saws, 12 lath saws, and 4 clapboard saws. There were also two planning machines, a gristmill, a cant dog factory, and two match factories.

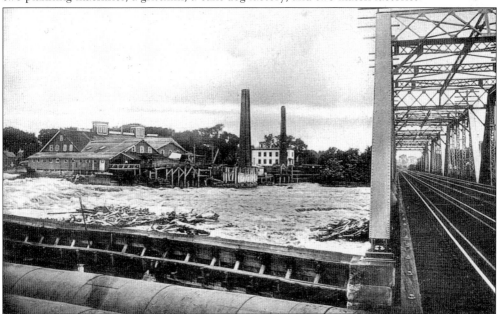

This postcard shows the view of the Engel mill and Monitor Hall from the Tough End. According to Dr. Glanville, both structures were badly damaged in a fire in 1892. Workers in the mill had to escape via the logs in the river and the Monitor fire engine was caught inside the building and destroyed, prompting the construction of a new Webster side firehouse, which still stands today.

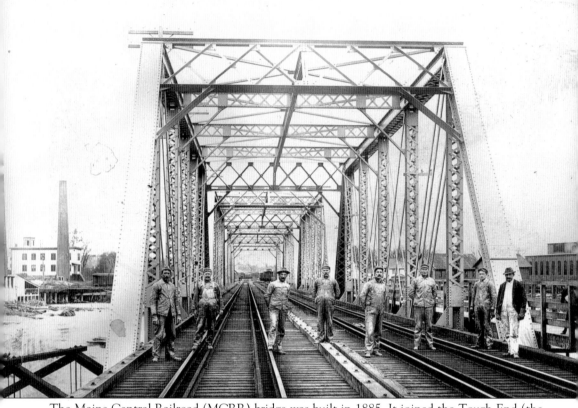

The Maine Central Railroad (MCRR) bridge was built in 1885. It joined the Tough End (the Orono neighborhood below the railroad tracks) and the Webster side (located on March Island). Originally, each neighborhood had its own railroad station. The Tough End station can still be seen at the corner of Plummer and School Streets—one block south of its original location. To the right of the rails, a pedestrian walkway can be seen. This was affectionately known as "the longest bar in the world" to local residents. Below the bridge is the paper mill for International Paper. Once the Central Fire Station was built on Bennoch Street, the town decommissioned Monitor Hall (the white building to the left of the bridge) and sold it to the Engel mill. After the Engel mill burned in 1914, International Paper bought the building to use for Christmas parties, dances, and other social events. Monitor Hall is now a private residence.

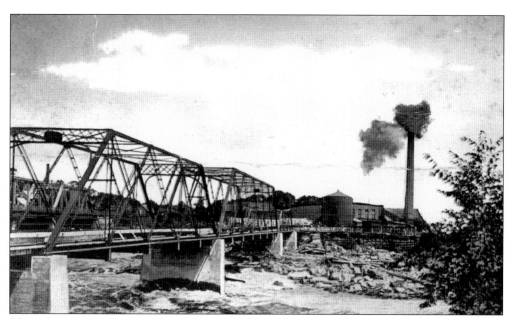

The pulp portion of International Paper came from the mill on the south side of the Stillwater and was then transported across the river via the bridge pictured on this postcard (the MCRR bridge is visible on the extreme left). Some local residents still remember riding across the river on this pulp carrier as children, long before the first Occupational Safety and Health Administration (OSHA) regulation was instituted.

Standing in the shadow of the pulp wood pile for International Paper (visible in the upper left-hand corner) is "Buttons" Cota. The pile used to be located on Water Street between the main MCRR line and the spur line that ran upriver to Stillwater. The tallest portion of the pile was loaded by a conveyer. Behind Cota to the right is the smokestack for the International Paper mill.

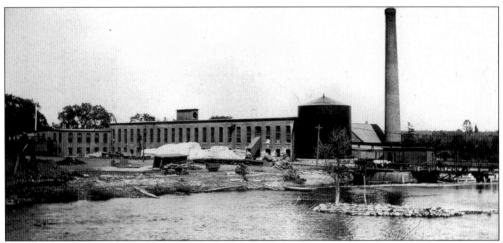

The Webster mill was built in the late 1870s or early 1880s. Sometime later it became part of International Paper, producing newsprint until the 1920s, when the company built faster machines in Canada. During the Depression, the mill enjoyed the reputation of being the producer of superior hanging papers, or wallpaper. Paper production ended in 1942, but the machine shop in the mill hung on until 1944 by making cast steel parts for 90 millimeter guns.

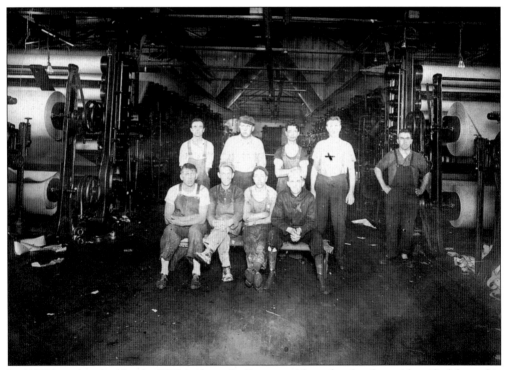

Jesse Wilson (marked by the "X") is the only Orono resident that has been identified from this 1920 photograph of workers posing between two of the paper machines at International Paper. Before the mill found success in making wallpaper, other similar types of paper were tried, including pencil tablet paper for schoolchildren.

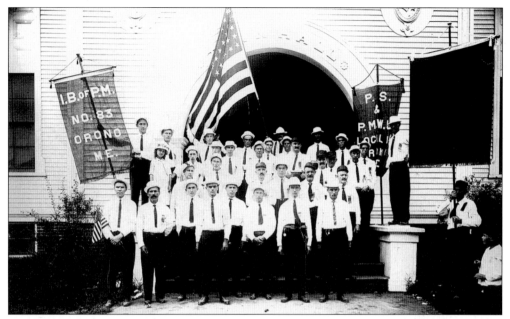

Jesse Wilson (second from the right in the third row) and Bill Denning (third from right in the second row) are the only Orono residents that have been identified from this 1920s photograph of the International Brotherhood of Paper Makers union. Another papermakers union seems to be posing with them on the steps of the town hall.

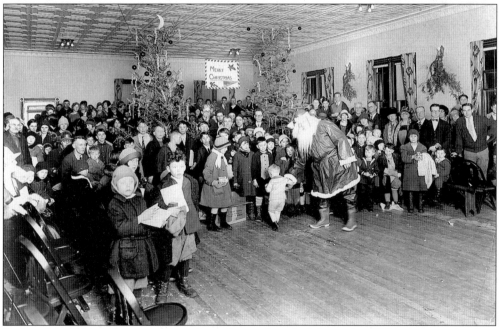

Only a handful of Orono residents have been identified from this 1928 photograph of an International Paper Christmas party being held at Monitor Hall. They are Joseph and Leonard Chase (on the far left in the first row), Harold LeClair (the boy with the tie looking around the girl with the hat), and Walter Baker (with the round glasses and bow tie on the far right). Santa seems to be returning one over-anxious partygoer to his place.

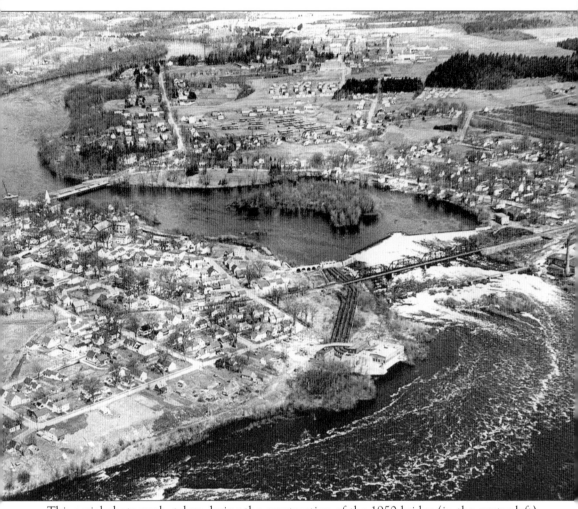

This aerial photograph, taken during the construction of the 1950 bridge (in the center left), illustrates many of the changes Orono underwent during the last century. The sawmills, cant dog and match factories, and pulp mill are all gone. The International Paper mill (in the center right) has been closed for five years. Byers Manufacturing (the large building to the right of the new bridge), Shaw & Tenney (just above the railroad tracks at the south end of the MCRR bridge), and the Striars shoddy mill (just out of the picture in the lower left-hand corner) represent the last manufacturing efforts in a town once known for its industrial might. The town, about to celebrate its sesquicentennial in 1956, is entering the postindustrial phase of its urban development, which will be dominated by the University of Maine. The campus is starting to stretch out, as seen in the upper portion of the photograph.

## Four

# EQUAL TO THE ADVANTAGES
# OF THE BEST ACADEMIES

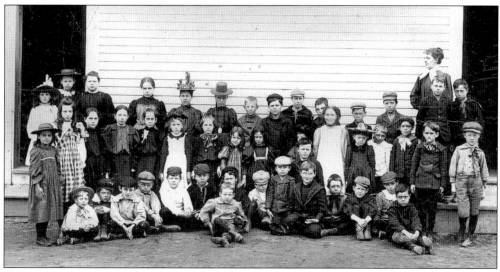

Pictured here are the students of Primary No. 2 from the 1894–1895 school year. Frances Mosher is the teacher. The following students are in the photograph: Raoul and Elmer George, Willis and Florence Harvey, Harry Woods, Harry Marshall, Willie Goodwin, Avery Hammond, Angie and Leo Shatney, Elizabeth and Charles Goggin, June Farest, June Page, Delcina Gardner, Hazel and Charline Shatney, Richard Powers, Merle Rolfe, and Dunton Hamlin.

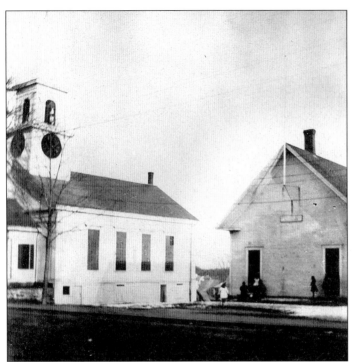

As this photograph illustrates, Primary No. 2 was located on Main Street next to the Universalist church. Built in 1828, it served as a school building into the 1920s. Next, it was used as the home for Orono's American Legion post. It was later converted to apartments and then torn down after a fire in February 2003.

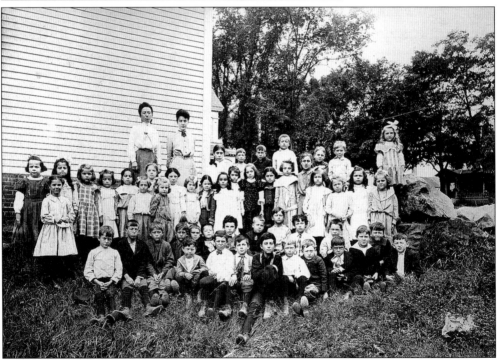

Charles Byron "Hi" Smith is at the extreme left of the first row of this Primary No. 2 photograph from the early 1900s. He later worked for the post office in Orono. Barbara Dunn is the 12th girl in from the left. She was the daughter of Charles Dunn, a local lawyer who became a chief justice on the Maine Supreme Court.

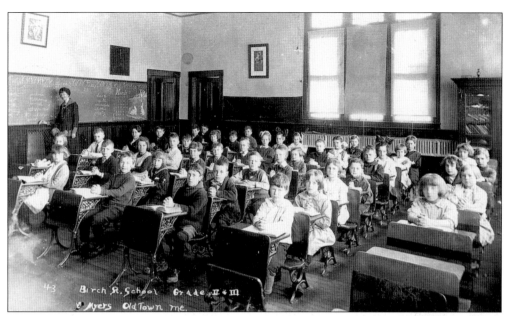

This interior photograph shows school life in the early 1920s for second- and third-grade students at the Birch Street School. In 1936, the Birch Street School performed *Peter Rabbit* at the town hall (which was the site of many shows and dances in the early part of the last century). Listed on the program were 126 children, including 17 with individual parts from the book by Beatrice Potter.

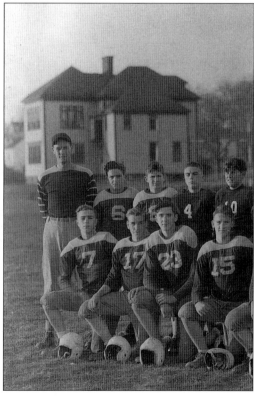

The Birch Street School (seen in the background of this 1944 Orono High School football team photograph) was originally constructed in 1900–1901, and was enlarged from two to four rooms within a few years. The building served as a school until Asa Adams Elementary was built in 1957. In the 1970s, it became a senior citizen center and a thrift shop.

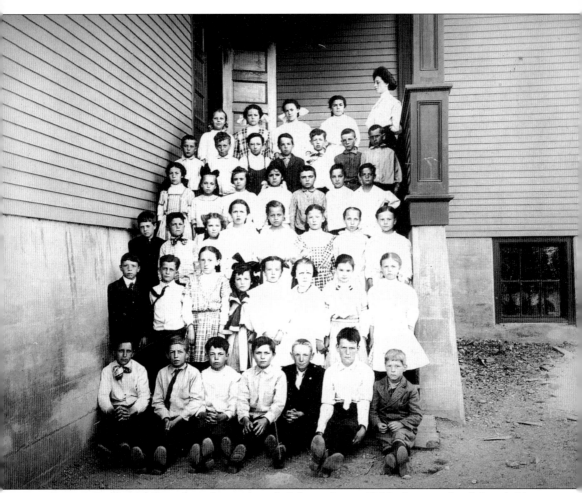

Several Orono residents have been identified from this *c.* 1910 photograph of the children attending the Webster School. They are, from left to right, as follows: (first row) three unidentified students, Lester Cowin, Ralph Monahan, Norman Martin, and Walter Littlefield; (second row) Wilfred Doucette, ? Brooks, Charlotte Doyle, ? Fournier, Madeline Lord, Ly Walker, Louise Baker, and an unidentified student; (third row) Freddie Babbin, Cliff Fournier, unidentified, Ruth Logan, Ruth Edgecomb, two unidentified students, and Delia Commeau; (fourth row) Eva Farnsworth, unidentified, ? Sullivan, ? Clement, unidentified, Harold Modery, and Everett Murch; (fifth row) Leroy Wright, Teddy Bartlett, Winfield Spencer, ? Therault, Clayton Sawyer, George Morrison, and George Johnson; (sixth row) Verna Walker, Margaret Morrison, Mina Therault, Lucille Clement, and teacher Miss Haley.

The Webster School (on the left) was located on North Main Street. It was built in 1910–1911 in response to overcrowding in Orono's schools. Like the Birch Street School, it was decommissioned when Asa Adams Elementary was opened in the late 1950s. Unlike its sister school, however, the building was torn down in 1974.

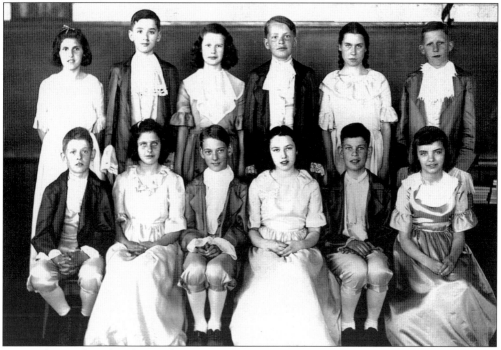

Not to be outdone by the Birch Street School, the Webster School had its own theatrical productions. Pictured here are members of the Morris Dance dance troupe. They are, from left to right, as follows: (front row) Eddie Babbin, Teresa McGinn, Alton Moore, Phyllis Pratt, Alfred Gallant, and Jean Wallace; (second row) Rose Lyons, Robert Thomas, Lois Ann Small, Evan Turner, Mary Weymouth, and Herbert Cowin.

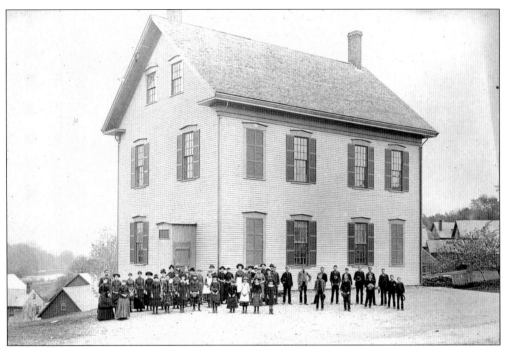

This is how the Bennoch Street School looked before the front porch was added. The structure was built in 1851 and served initially as Orono's high school and town office. After the new high school was built in 1903, the building housed the grammar school on into the 1930s.

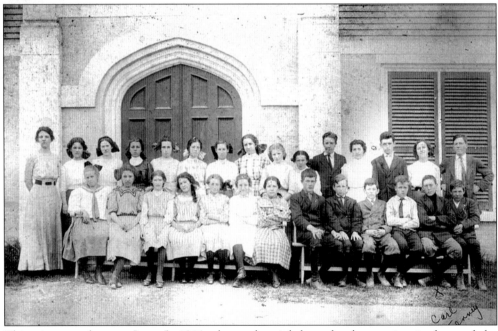

This picture, taken on June 5, 1911, shows the eighth-grade class posing in front of the Congregational church on Bennoch Street. Only a handful of these students have been identified. They are Barbara Dunn (third from the left in the first row), Charles Smith (eighth from the left in the first row), and Carl Tenney (twelfth from the left in the first row).

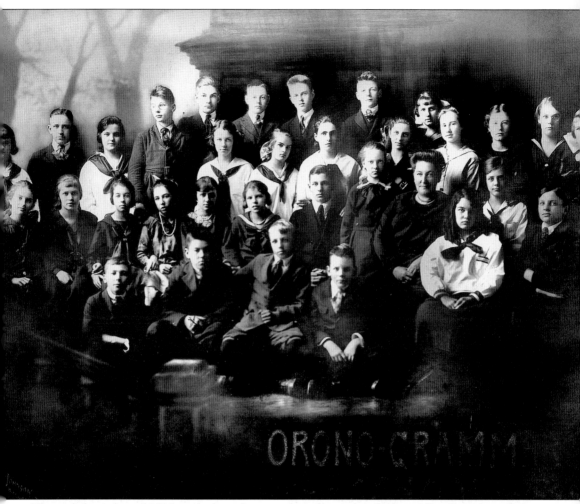

The eighth-graders of 1919 might have been reading the works of Edgar Allan Poe when they chose this backdrop for their class photograph. Seen here are, from left to right, the following: (first row) Alvin Myers, Harold Read, Ernest Littlefield, "Sonny" Mursur, Dorothy Grindle, and Eben Webster; (second row) Maggie Wilson, Lillian Goodine, ? James, Melva Littlefield, unidentified, Fanny Perkins, Harold Powell, Pearl King, Alice Hathorne, and Jessie Ashworth; (third row) two unidentified students, Florence Conrad, Dellia Rich, unidentified, Alta McDonald, Isobel McDonald, and Blanche King; (fourth row) Annie Morrison, Charles Dore, Mena Gass, Earl Treadwell, Forrest Keene, Phillip Plourde, James Berry, Rosco Varney, and Vivian Sinclair. Of all the schools over all the years of public education in Orono, the eighth grade is by far the best-represented class in the collection of the Orono Historical Society.

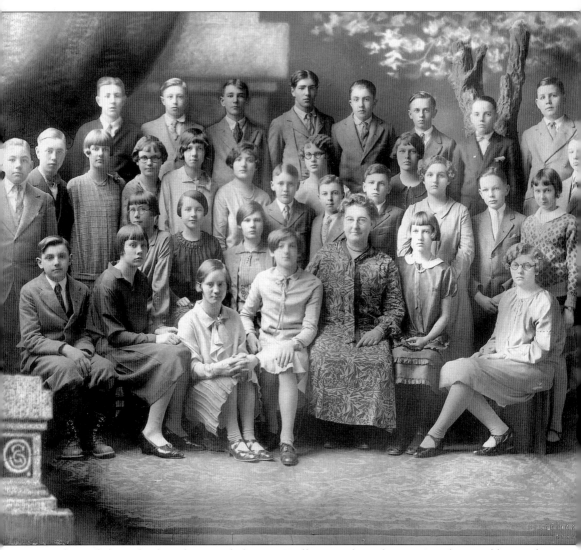

This eighth-grade class photograph from 1927 illustrates how the Jazz Age dress and hair styles had reached Orono by the end of the 1920s. Seen here are, from left to right, the following: (first row) Edward Gerrish, Rachel Wallace, Eva Goodrich, Nellie Gass, Alice Hawthorne (affectionately known as "Grammie"), Mildred Willard, and Ruth Rogers; (second row) Ruth Barrows, Mary Perry, Marcia Varney, John Small, Joseph Murray, Loren Hodgeman, Prudence Hayes, George Stinchfield, and Virginia Palmer; (third row) Llewellyn Spencer, Harry Day, Irene Smith, Dorothy Powers, Beatrice Piper, Bertha Pepper, Louise Gibbs, Lucy White, and James Boardman; (fourth row) William Gerrish, Richard Willard, Louis Silver, Frederick Myers, Edwin Mann, Leroy Barry, Kenneth Baker, and Linwood Perkins. Of note from the class photographs is the number of names that are repeated over the two decades, as well as the number of names that are linked to local businesses.

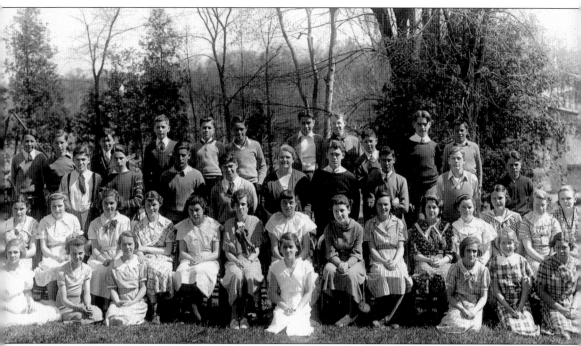

The eighth-grade class of 1935 had its class picture taken overlooking the Stillwater and the new bridge. Seen here are, from left to right, the following: (first row) Hester Sears, Josephine Sonya, Joan Cota (King), Margaret Carruthers, Helen Myers, Elva Hutchins McIntosh, and Louise Oliver; (second row) Corinne Campbell (Gordon), Helen Deering, Alice Robertson (Hilton), Helen Barrett (King), Frances Delong, Elzora Wing (LeClaire), Mary Ashmore, Janet Keene (Roy), Florence Kenny, Helen Stairs (Craig), Beulah Waters, Barbara Richardson (Ratchell), Marie King (Pelletier), and Ruth Darrah (Barnett); (third row) Abe Pepper, Walter Read, John Gibbs, Wilfred Commeau, Anna Dority Gerow, Ralph Powell, Joe O'Dell, Laurie Spencer, and Lawrence O'Leary; (fourth row) Charles Swindle, Homer Richardson, Emery Sears, Robert Jenkins, Franck Spencer, Bob DeGrass, Ray Cunningham, John Dickinson, George Casey, Alphius Cameron, and Hayford Clement.

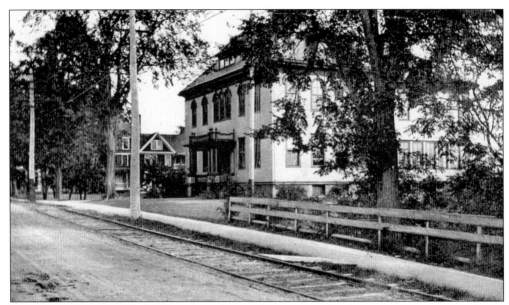

This postcard illustrates the second Orono High School, which was built in 1903 to accommodate the rising number of students due to the increasing population of the town. Note once again the trolley tracks that used to run along Main Street. The Estabrooke house, visible on the left, is still standing.

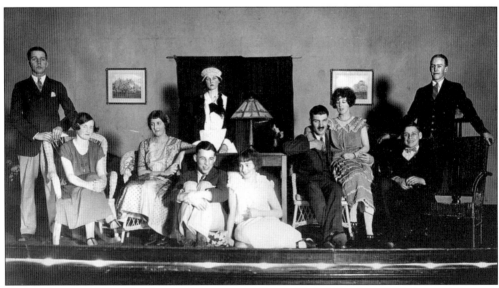

Here is the cast of *Kitty Benders*, a play put on at Orono High School in 1925. James Ashworth and Lillian Clark (Wilson) have been identified in the front row. Doris Farnsworth is the third person from the right. Other cast members include Edward Kelly, John Osgood, Homer Huddleston, Basil Vaughn, Lillian Clark, Eunice Barrows, Dorothy Gustin, and Betty Glover.

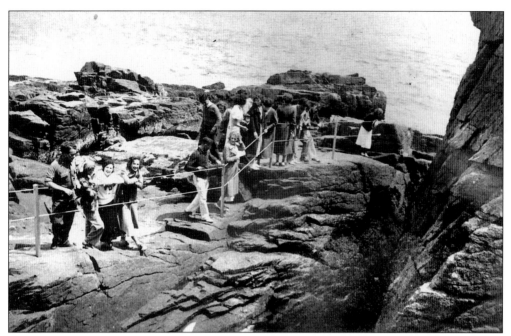

This photograph shows the class of 1936 visiting the Thunderhole on a trip to Acadia National Park. According to Charlie Smith, the photographer, the class traveled to Mount Desert Island by car, toured the park, and saw a movie in Bar Harbor, a full day for Depression-era Maine.

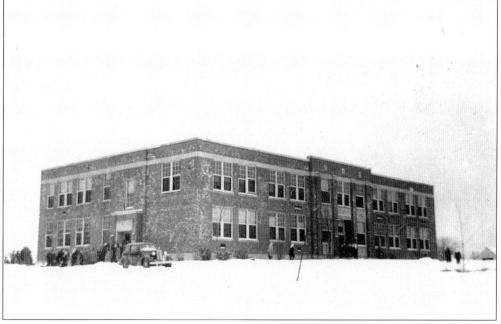

The new high school was built in 1938. It still stands today and serves as Orono's middle school. The present high school is located in a new building that is attached to its predecessor. According to Dr. Glanville, Orono's first teacher's association was formed in June 1860. It met monthly in the basement of Orono's first high school on Bennoch Street to help teachers with lesson plans and discipline.

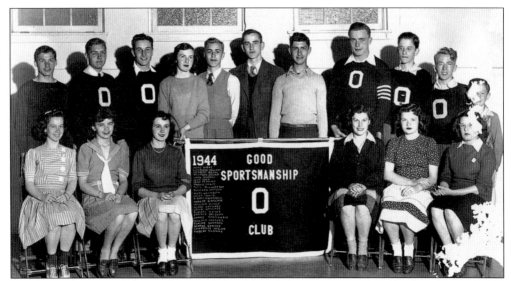

The 1944 members of the Good Sportsmanship Club at Orono High School are, from left to right, as follows: (front row) June Cota, Jean Wallace, Shirley Doten, Beatrice Burton, Elaine Connors, and Ruth Grindle; (back row) Lawrence Gallant, Bill Oliver, Dick Watson, Mary Dirks, George Gonyar, William Vasquez, Donald Brideau, Jim MacKenzie, Lawrence McGinn, Sidney Goodspeed, and Bobby Sinclair.

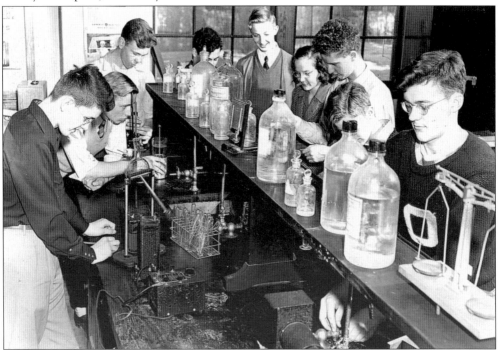

Seen here are members of the 1946–1947 Science Club at Orono High School. They are, from left to right, Dwight Demeritt, Charles Allen, Joe Haverlock, unidentified, Howard Runion, Carol St. Lawrence, Paul Cloke, Lawrence Gould, and Donald Smyth. Members participated in science fairs at the local and state levels and were encouraged to tinker in the lab at their weekly meetings.

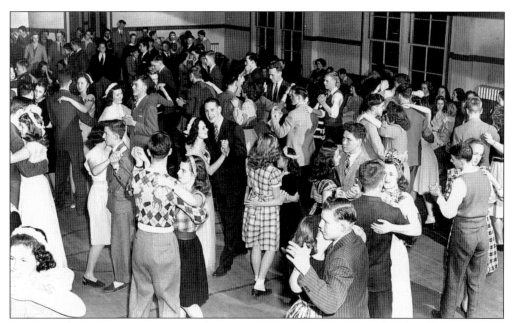

Everyone that was anyone went to the winter carnival at Orono High School in the 1940s. The dance, which took place at the town hall (note the markings on the wooden dance floor), also featured a queen and her court and skits presented by each of the classes from grades seven to twelve.

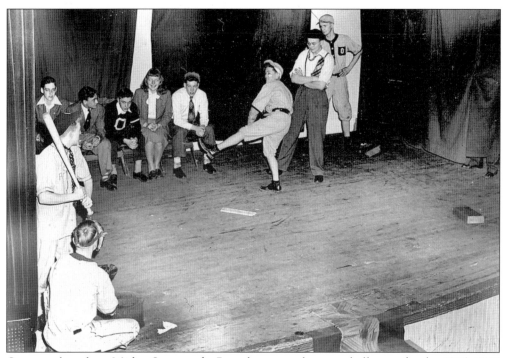

Cast members from *Mighty Casey at the Bat* rehearse at the town hall stage for the 1946–1947 school play. Members of the senior class typically staged a production of their own every year, in addition to productions put on by the drama club.

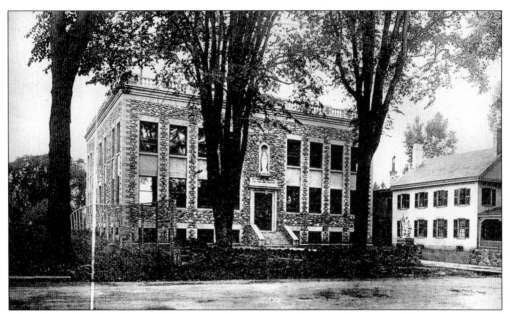

This postcard shows St. Mary's School, which opened in September 1916. The school had 258 students in grades one through nine that first year. The number of pupils rose to 380 the next year, and the school employed four lay teachers to assist the Sisters of Mercy (teaching nuns). The building houses the Main View Apartments today.

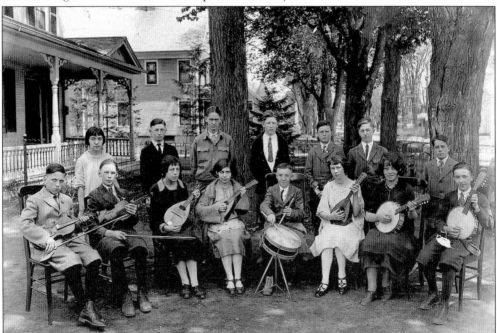

Pictured in this mid-1920s photograph is the first and only St. Mary's School Orchestra. Members are, from left to right, as follows: (front row) unidentified , Kenneth White, Ellen Soucie, Bella Caron, Austin Beaulieu, Gertrude Sullivan, unidentified, and ? Beaulieu; (back row) Alice Goodie, unidentified, Gerald Milheron, Roland Ouillette, Woodrow King, Denny Meigher, and Lee Cota.

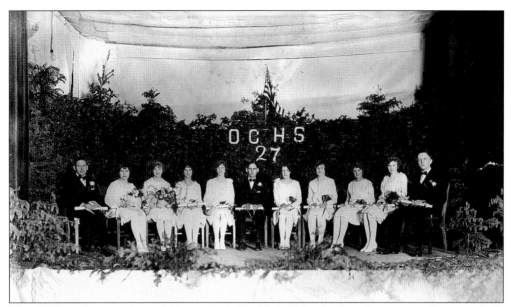

The 1927 graduating class of Orono Catholic High School takes the stage at the town hall. Seen here are, from left to right, Walter Hall, ? Rablin, Emaly Veano, Margaret Morrison, Ellen Soucie, Gerald Milheron, Theresa Leveille, Eleanor DeGrasse, Beulah Veano, Bella Caron, and Clifton Theriault. The first high school class from St. Mary's graduated in 1920.

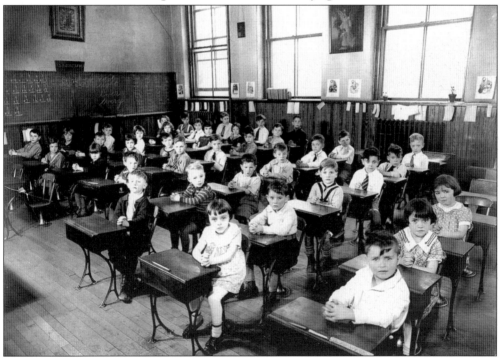

In this 1936 view, Sr. Mary Alice's subprimary (kindergarten), first-grade, and second-grade students pose quietly at their desks. In 1918, St. Mary's School had 400 pupils, with 58 of them being high school students. The high school closed its doors in 1960, and the grade school followed suit in 1967.

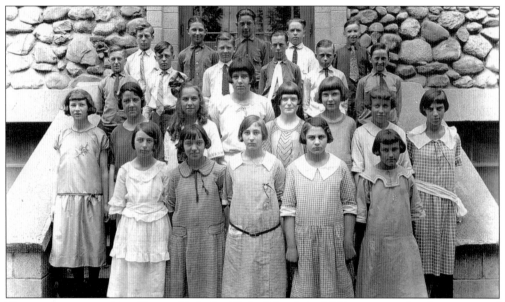

The students attending Orono Catholic High School in 1928 pose on the front steps of St. Mary's School. Seen here are, from left to right, the following: (first row) Alice Currier, Alice Goodine, Irma Prue, Evangeline Castonguay, and Mildred Hogan; (second row) Gertrude Sullivan, Bernice Sullivan, Virginia Lemieux, ? Pretto, Virginia Ware, Susan Guice, Thelma Fortier, and unidentified; (third row) "Dinny" Maher, ? Richards, Roland Willette, Ernest Dean, Albert Lemieux, and John Samways; (fourth row) "Freddy" Richards, Stanley Commeau, Francis Mallett, Howard Dore, and Austin Beaulieu.

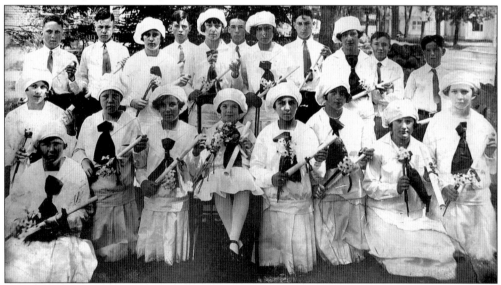

In this 1926 graduation photograph are St. Mary's School students. They are, from left to right, as follows: (first row) Kay Samways Prinn; (second row) Dorothy Babbin, Helen O'Leary, Catherine Pelkey, Frances Doyle, Martina Currier, Lucille DeGrasse, Victoria Woods, and Josephine Voter Richardson; (third row) Catherine Johnson, Margaret Commeau, Stella Thibodeau, and Evelyn Therriault, (fourth row) Wilfred "Buddy" Peters, Lawrence Hogan, Arthur Libby, David Mitchell, Clarence Deveau, Aston Beaulieu, and Karl Cota.

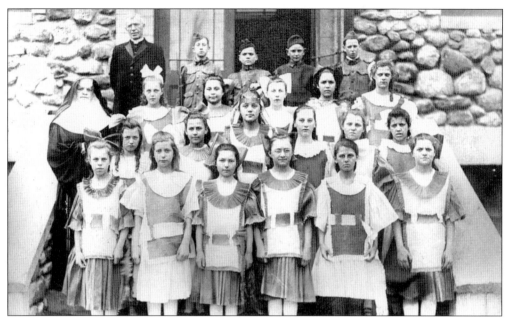

Cast members of the annual St. Patrick's Day concert pose c. 1918 on the front steps of St. Mary's School. They are, from left to right, as follows: Cora Dean, Rose White, May Thibodeau, Pauline Buribye, Leona Currier, and Blanche Castonquay; (second row) Eleanor Fitzherbert, Sylvia Hogan, Selina LeClair, Mabel Alexander, Evelyn Smith, and ? Theriault; (third row) Sr. Mary James, Dorothy McCann, Margaret Johnson, Anna Chamberlain, Doris Hashey, and Beatrice Robichaud; (fourth row) Fr. John Harrington, John Budway, William Goodie, Walter Baker, and Warren Sullivan.

This photograph from the late 1940s shows the St. Patrick's Day play put on by the students of St. Mary's School on the stage of the town hall. Note how the war theme of the previous photograph has been replaced with a western theme in this later show.

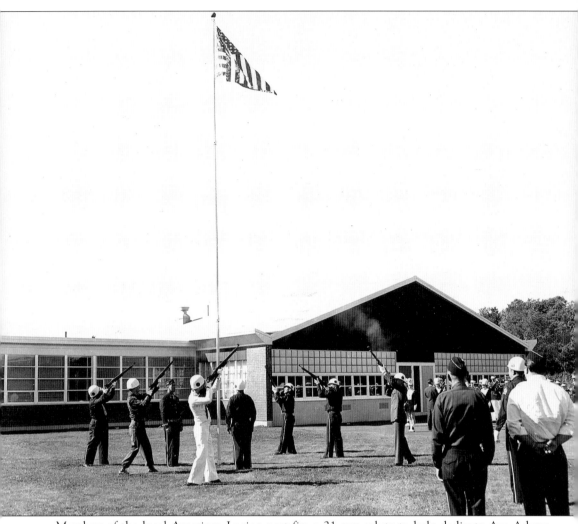

Members of the local American Legion post fire a 21-gun salute to help dedicate Asa Adams Elementary School in 1957. Named in honor of a local physician, the school took the place of both the Birch Street and the Webster Schools. This building continues to house kindergarten through fifth grade today. By 1957, Orono had already celebrated its sesquicentennial and had taken significant strides in public education from its first town meeting in 1806, which prompted Gov. Israel Washburn to remark, "Having made provision to prevent the straying of cattle and the dead, they seemed to have thought it reasonable to let the children run at large."

*Five*

# TO SPEED THE PLOW
# AND FATTEN THE CROP

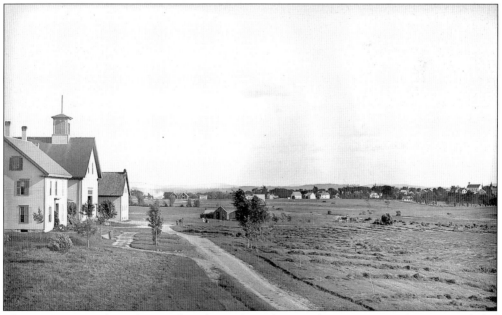

The *c.* 1900 view from the Maples, the working farm at the University of Maine, included Orono's town hall and the steeples of its churches (on the far right). In 1865, Orono was selected as the site of the agricultural and mechanical arts college due, in part, to its location close to the geographic center of the state. Classes did not start, however, until three years later.

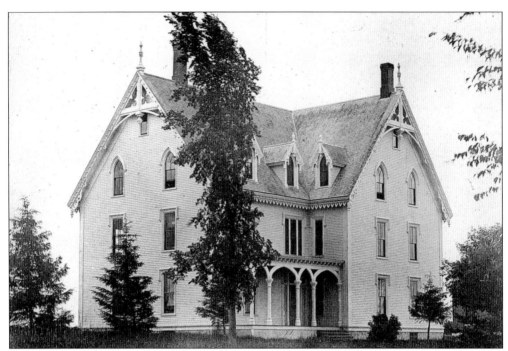

White Hall, constructed in 1868, was the university's first dormitory and classroom. Charles Allen, the first president, and Merritt Fernald, the first faculty member and second president, had their offices on the second floor. The building was destroyed by fire in 1890, and Wingate Hall was built on the same site.

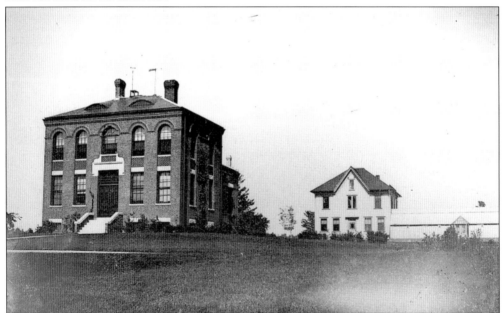

This photograph from the late 1880s or early 1890s shows the original appearance of Holmes Hall, which initially served as the home of the government-run agricultural experiment station. Wings were added to either side of the building in 1899 and 1904. Next to Holmes Hall is an early university greenhouse.

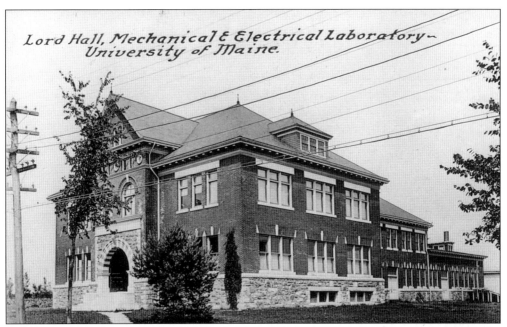

Named for an early trustee, Lord Hall was constructed in 1904 to serve as the home for the mechanical and electrical engineering laboratories. It is still in use today and will soon house the art department at the University of Maine.

In the earliest days of the university, students helped to defray the expenses of their education by working on the farm. According to David Smith's history of the university, *The First Century*, student workers dug 700 bushels of potatoes in 1869 and reduced the cost of their board by 33 percent—paying just $2 instead of $3.

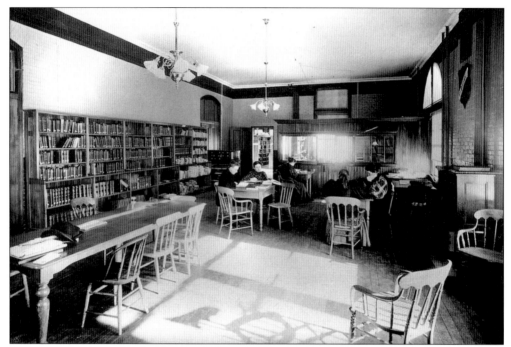

University students can be seen here cracking the books in the early morning light at the school's first permanent library in Coburn Hall. The university's earliest library was a small room located in one of the recital halls. According to David Smith, it was only open two hours a day until the 1890s, and the faculty took turns serving as the librarian.

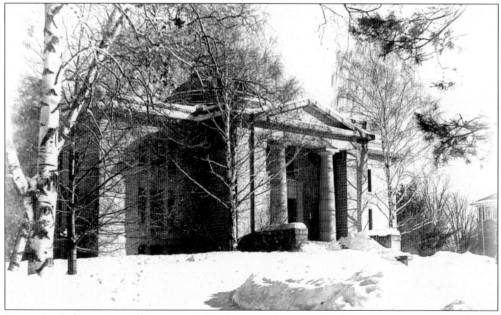

Using funds from the well-known philanthropist, Carnegie Hall was built in 1903 to be the university's new library. Carnegie Hall served in this capacity until after World War II, when Fogler Library was completed. The building now houses offices and gallery space for the art department, retaining its distinctive appearance.

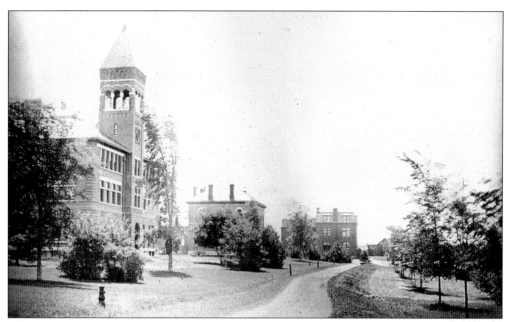

Wingate, Fernald, and Coburn Halls face the Stillwater River in this photograph from 1893. Wingate's clock and bell tower were lost during a fire in 1943, but the rest of the building survived. Fernald was originally known as Chemical Hall and was constructed with 264,000 bricks made by university students as part of their education, according to David Smith.

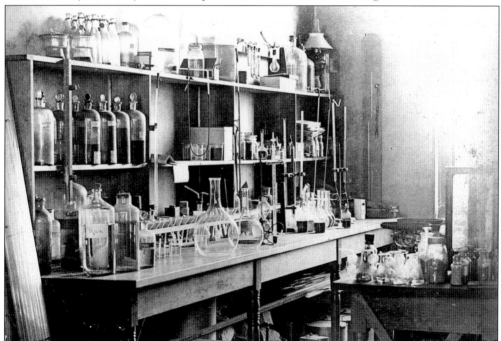

Early in its long history of service to the University of Maine, Wingate was the home to various engineering departments, as well as physics and chemistry. This photograph from the early 1890s illustrates the typical student lab of the era. Today, the building houses the planetarium and administrative offices.

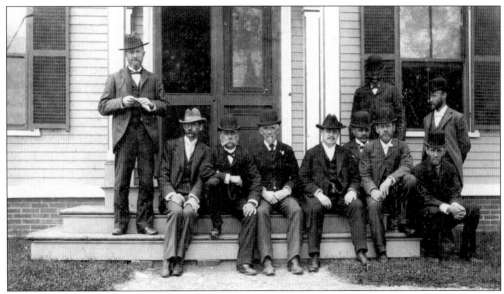

This is a portrait of the university's faculty *c.* 1897. The members are, from left to right, as follows: (seated) Walter Balentine, Allan Rogers, George Hamlin, Frank Damon, Alfred Aubert, Horace Estabrooke, and Walter "Jim" Flint; (standing) Lucius H. Merrill, C. H. Fernald, and James Bartlett.

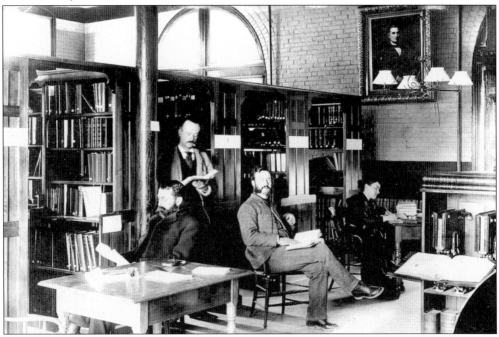

Faculty members demonstrate the comforts of the library in Coburn Hall *c.* 1895. Seen here are, from left to right, Prof. Horace Estabrooke (who graduated in 1876 with his bachelor's degree and in 1884 with his Master of Science), Frank Damon (Class of 1895), Prof. Allen Rogers, and Harriet Fernald (the university president's daughter who graduated in 1884 with her bachelor's degree and in 1888 with her Master of Science). A painting of Charles Allen, the university's first president, hangs on the wall.

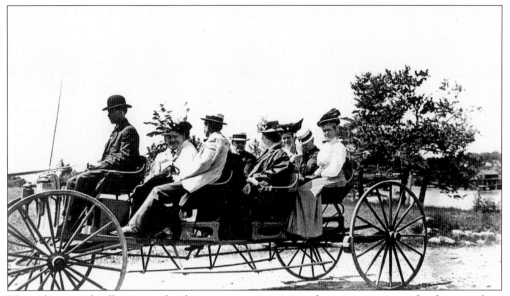

This photograph illustrates the leisure-time activities of some university faculty members c. 1900. They have been identified, from left to right, as follows: (first row) Prof. David Chase (Latin), Roselle Huddilston, and Paddy Huddleston (art); (second row) Prof. Hanes and unidentified; (third row) Bertha Stevens, James Stevens (dean of the College of Arts and Sciences), and Alice Hart.

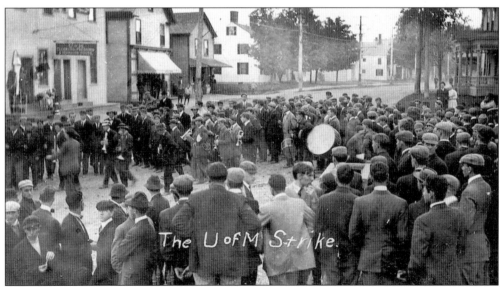

Seen are members of the "Light 800" as they rally in Monument Square during the student strike that took place in October 1909 to protest the student suspensions handed down after a night of illegal hazing activities (including river dunking and heavy paddling). The entire college—with the exception of the football team, which had a shot at the state championship that year—cut classes to march around the track. The strike lasted nine days.

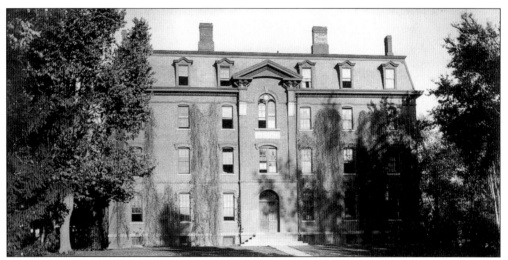

Oak Hall was one of the earliest dormitories at the University of Maine. It burned in January 1936 and was replaced with a larger dormitory building (also named Oak Hall) that still stands in the same spot.

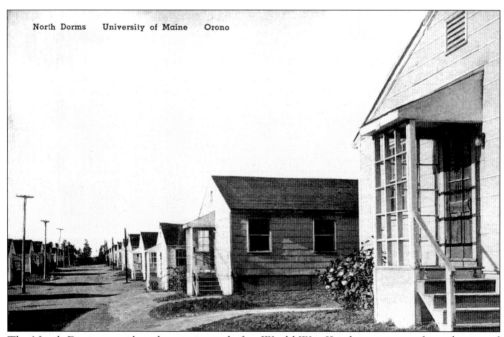

The North Dorms were hastily constructed after World War II, when veterans from the armed services flooded the campus. According to David Smith, the enrollment at the university in 1947 was 4,000 students, with 3,000 of them being veterans. Families were housed in the South Apartments, called the "Fertile Crescent" by some.

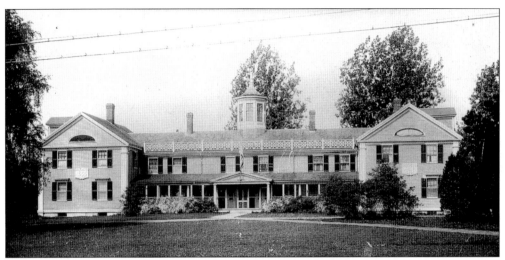

Mount Vernon House was originally one of the university's first farm buildings. It was remodeled and used as a dormitory for women in the early 1900s. Next, it served as the living quarters of bachelor faculty members. It burned in 1933.

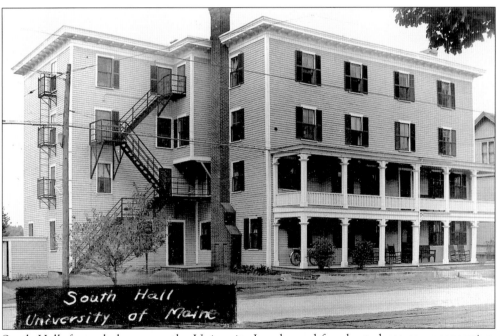

South Hall, formerly known as the University Inn, housed female students as a cooperative, self-service dormitory from 1935 until after World War II. Prior to that, it housed single faculty members.

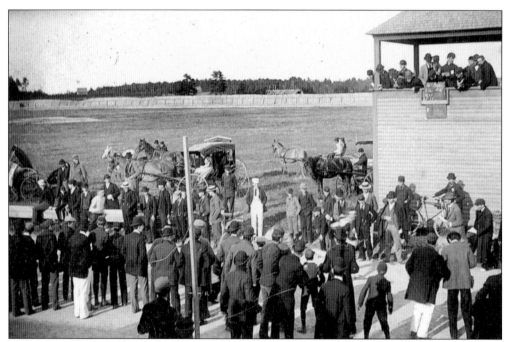

The photographs on this page illustrate a track meet at the university in the 1890s, judging by the velocipede at the base of the reviewing stand in the upper photograph and the styles of the carriages in both views. Could those be betting stubs in the hands of some of the spectators waiting at the finish line?

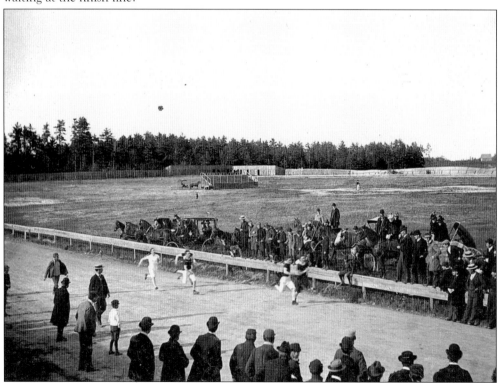

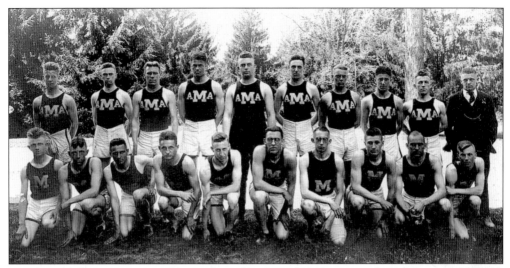

Members of the university track team from the class of 1913 are seen here. They are, from left to right, as follows: (front row) two unidentified men, John Hart, Carleton Lutts, Allen McLary, George Hamlin, John Littlefield, unidentified, Arthur Cannon, and Howard Burgess; (back row) unidentified, Hubert Wardwell, unidentified, Elson Bigelow, James Church, John Carleton, two unidentified men, Edward Chase, and ? Savage. The letters on their shirts stand for College of Agriculture and Mechanical Arts.

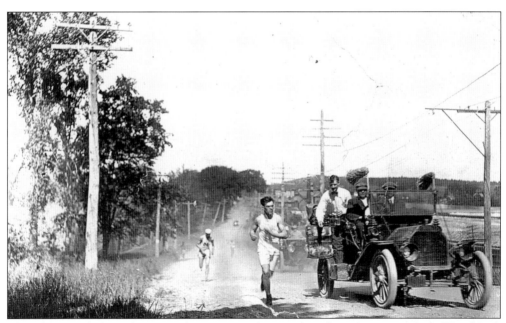

This photograph from the 1920s shows a 10-mile marathon from Orono to Maple Wood Park in Bangor. The winning time was 1 hour, 13 minutes, completed by a runner from Bangor High School. The runner from the University of Maine (most likely the runner in the foreground) came in last, with a time of 1 hour, 25 minutes.

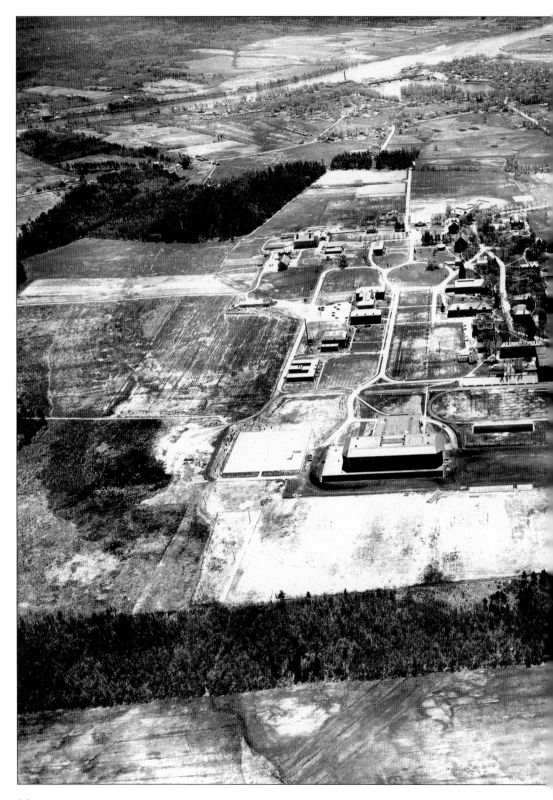

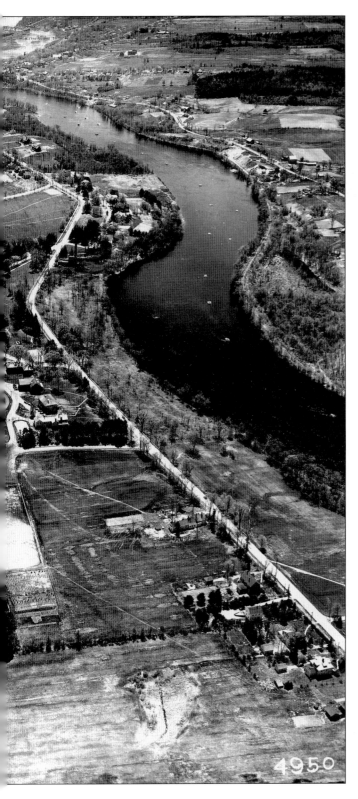

4950

This late-1930s photograph by the Holmberg Aerial Survey Company shows the university campus and the town of Orono and illustrates the campus and town before the campus experienced a period of significant expansion. Note the absence of Fogler Library (built as a shell during the war and completed afterwards) and the Memorial Union (also completed after the war). The configuration of the athletic fields on the north side of campus is also different from today. Note also how Stevens Hall (with its north and south wings) is one of the few buildings on the east side of the campus. At this point in time, the focal point of the campus is still the river running past it (just out of view to the right). Soon, the expansion to the east will realign that focus to the axis between the field house (next to the track in the foreground) and Fogler Library at the opposite end of the mall.

87

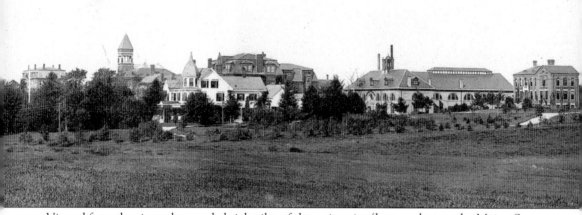

Viewed from the river, the stately brick piles of the university (known then as the Maine State College of Agricultural and Mechanical Arts) reflect the growth c. 1900. They are, from left to right, Oak Hall (only the roofline is visible), Wingate (easily identified by its tower), the president's residence (the distinctive Victorian cupola was in place by 1893, added after changes made due to fire and remodeling), Coburn Hall, Alumni Hall (constructed as a drill hall and gymnasium, also the site of chapel meetings and student dances), and Holmes Hall (with its first wing in place, dating the photograph between 1899 and 1903).

## Six

# Undefeated and Unscored Upon

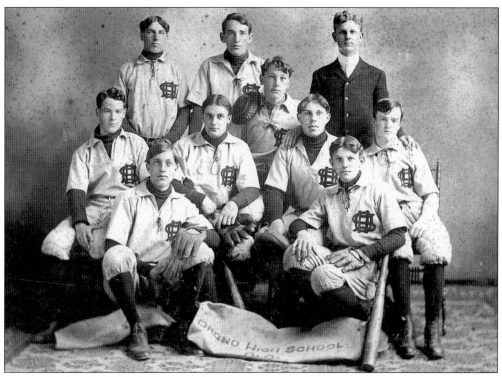

Orono's high school baseball team of 1904 went 7-1 under its captain, Leon S. Dixon, and manager, R. L. Hammond. The players are, from left to right, as follows: (first row) ? Stevens, right fielder; and H. E. Sutton, left fielder; (second row) Phil Crowell, second baseman; George Hamlin, shortstop; Lean S. Dixon, catcher; and C. Goggins, pitcher; (third row) ? Fiwi, third baseman; ? Clifford, first baseman; A. Hammond, center fielder; and R. Hammond, manager.

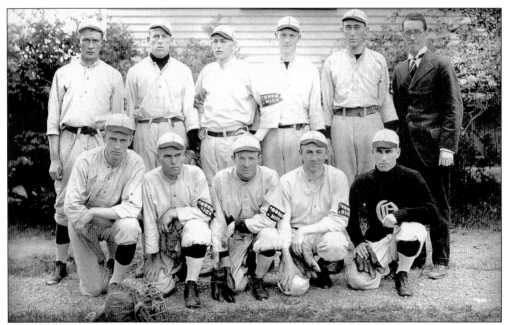

The 1916 Orono High School baseball team poses next to the Birch Street School. Seen here are, from left to right, the following: (front row) Phil Haswell, catcher; Ernest Sullivan, second baseman; Leo Kenney, shortstop; John Beaulieu, third baseman; and Alan Sullivan, center fielder; (back row) C. Byron "Hi" Smith, pitcher; William "Pat" Dore; Clarence "Tike" Cowin, second baseman; Clayton "Mutt" Page, outfielder; Carl Tenney, first baseman; and Clarence Chatto, coach. Orono's baseball team won the Penobscot Valley League Championship in 1917.

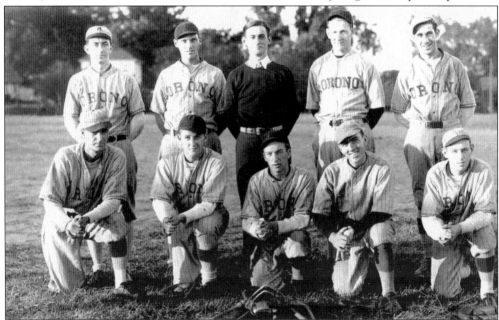

Members of the Orono High School team from the late 1930s are seen here. They are, from left to right, as follows: (front row) J. Alexander, A. Tapley, D. Mahar, J. Keegan, and H. Lancaster; (back row) M. Ronan, I. Lancaster, J. Howard, R. Willette, and J. Doucette.

90

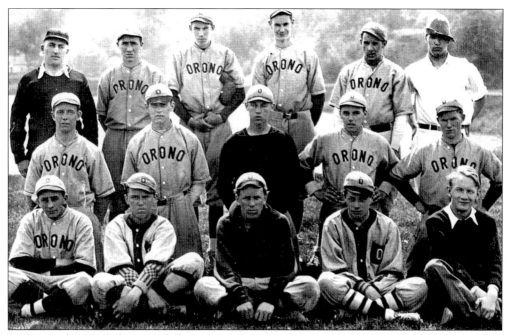

In this unidentified photograph from the early 1930s, members of Orono's high school baseball team pose for a photograph at Oriole Field. Behind them are the Frog Pond and the Basin, which used to have a ball field of its own that was made of sand.

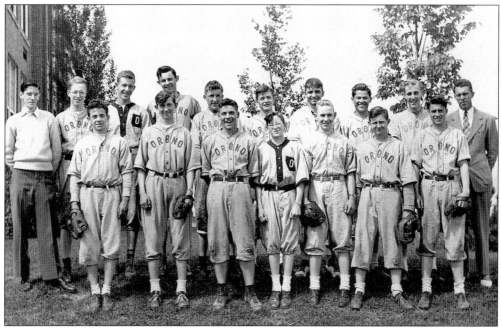

The 1946 version of the Orono High School baseball team looked like this. Members are, from left to right, as follows: (front row) Lawrence Bailey, Charles Sprague, Gerald Duffy, Ramon Atherton, Allan Fielder, Lawrence Redmond, and Edward Wilson; (back row) Lawrence McGinn (manager), Dwight Demeritt, John Needham, Philip Pedlow, George Crabtree, William Kenyon, Robert Wallace, John Littlefield, Robert Slosser, and Bernard Deering (coach).

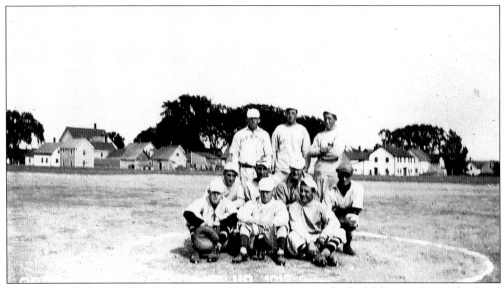

This postcard shows what the Orono Athletic Association looked like in 1913. The local papers also called them Orono Pulp & Paper because some of the players worked in the mill. This team played against the Ponies of South Brewer, who were associated with the Eastern Fine Paper mill. The picture was taken at the ballpark that would become Oriole Field, now the site of Longfellow Heights.

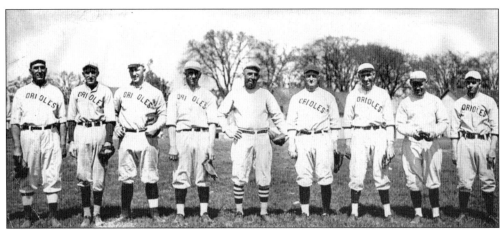

The Orono Orioles line up for a photo opportunity in 1915. According to local legend, this team scrimmaged with and defeated the Boston Red Sox at Oriole Field. They are, from left to right, Henry "Has" Prue, George "Dotty" Ambrose, Eddie Peters, Johnny Beaulieu, "Doc" Soucie, Pat McCann, Percy Chaplain, Leo Cota, and Fred Beaulieu. This town team also played games against local mill teams, like the Easterns of South Brewer.

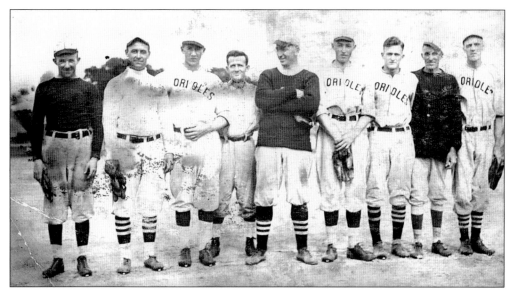

This picture appears to be from a 1918 exhibition game that took place before several of the Orioles went into the armed services. The team was broken into two squads, the Nuts and the Shells, with the former being pictured here. Members of the Nuts seen here are, from left to right, Leo Kenney, Leo Cota, Johnny Beaulieu, Joe Cota, Eddie Peters, ? Cowin, Fred Beaulieu, George Ambrose, and ? Tracey.

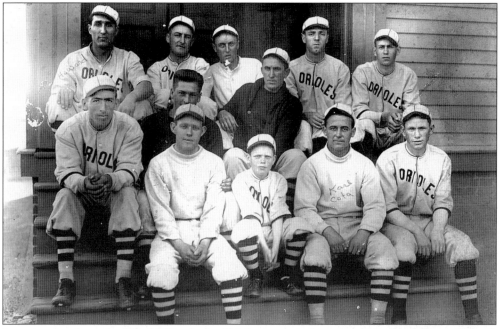

In a picture taken after World War I, the Orioles pose on the steps of the Birch Street School. The players are, from left to right, as follows: (front row) Doc Soucie, Stanley Cowin, Reggie Cowin, Leo Cota, and unidentified; (middle row) unidentified and George Ambrose; (back row) Henry Prue, two unidentified players, Johnny Beaulieu, and Freddie Gonyar. The Orioles played as a team until 1924, when several of their key players retired. Some of them, like Leo Cota, played on into the 1930s.

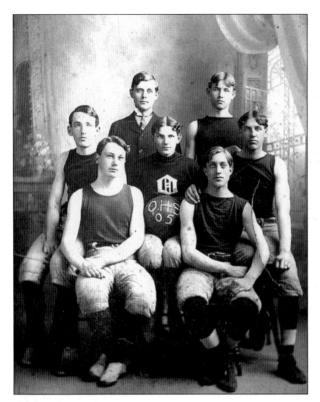

These members of the 1905 Orono High School basketball team have been identified using the team photograph from the baseball team of the same year. Seen here are, from left to right, the following: (front row) A. Hammond and Leon Dixon; (middle row) ? Clifford, Phil Crowell, and ? Fiwi; (back row) ? Stevens and R. L. Hammond.

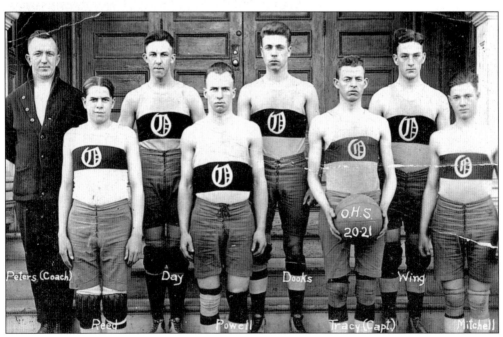

The members of the high school basketball team of 1920–1921 are, from left to right, as follows: (front row) Reed, Powell, Tracy (captain), and Mitchell; (back row) Peters (basketball coach in winter, Orono Oriole in summer), Day, Dooks, and Wing.

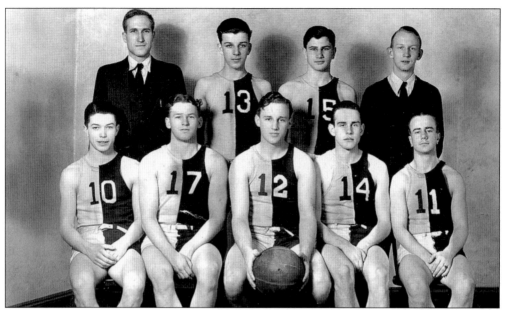

This *c.* 1929 photograph shows that the Orono High School basketball team adopted a harlequin look at the height of the Jazz Age. Members are, from left to right, as follows: Gene Bradstreet, "Bingo" Sullivan, Ted Fortier, Bud Baker, and "Beauty" Cota; (back row) unidentified (coach), "Crackers" Carruthers, Ralph Viola, and Gilby Ellis. Many times, only the nickname of the Orono resident has come down to us, as is the case with a few of these players.

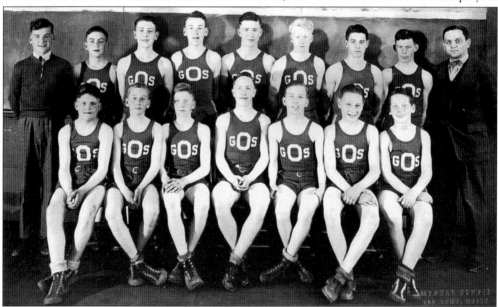

Proving that the high school was not the only place to play basketball in Orono, this photograph from the late 1930s shows that the grammar school got into the act as well. Seen here are, from left to right, the following: (front row) Dana Hashey, Harold Gallant, Danny Malloy, Roland Goodine, Alvin Richardson, Jack Hawkins, and Edward Snyder; (back row) G. Rand Anderson, Edwin Ambrose, Robert Myers, Edward Butler, Joseph Myers, Edward King, Francis Babbin, Roy Lozier, and Richard Starkey.

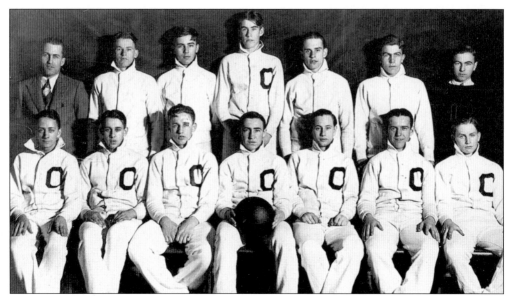

The basketball team at the high school adopted a more traditional look in this photograph from 1931. Team members are, from left to right, as follows: (front row) Clayton "Zeb" Shatney, Everett "Sunshine" Hatt, Edward "Teddy" Fortier, Aston "Red" Beaulieu (captain), Harry "Pie" Day, Karl "Tarl" Cota, and Gardiner "Blackie" Black; (back row) Walter Ulmer (coach), Everest "Bingo" Sullivan, Morley "Heifer" Myers, John "Slim" Hardy, Reginald "Buddy" Baker, Howard "Howie" Myers, and Joe Murray (manager).

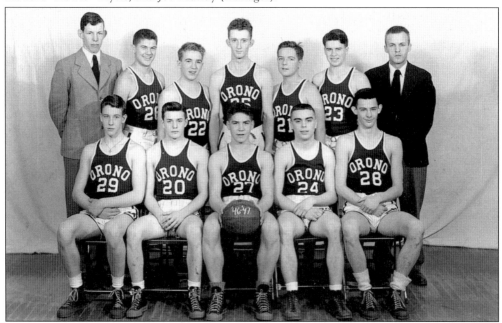

Jumping ahead more than a decade, this photograph shows the members of Orono High School's 1946–1947 basketball team. They are, from left to right, as follows: (front row) John Needham, William Kenyon, Gerald Duffy, Paul Burruby, and Philip Pedlow; (back row) Keith Cook (manager), John Littlefield, Sidney Goodspeed, John Atwood, Clarence Pelletier, Edward Wilson, and Karlton "Gus" Higgings (coach).

Gerald Duffy and Paul Burruby battle for the ball in this photograph of a game between Orono and Old Town from 1947, as spectators watch from the balcony of the old town hall. Two of the home-court advantages included the corners where the balconies acted as a sixth defender and the steam pipes at one end that Orono players could use to brand unsuspecting players of the other team.

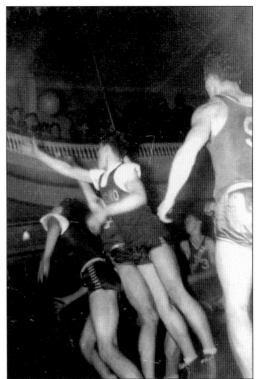

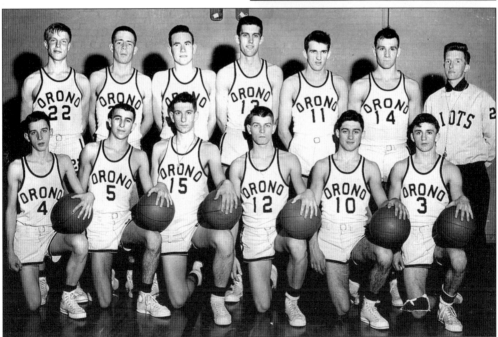

In this mid-1950s photograph are the players of the Orono Red Riots. They are, from left to right, as follows: (front row) Mark Shibles, Paul Prue, James Treadwell, "Cyc" St. Louis, Gary Goodin, and Ray Savoy; (back row) Gardner Hunt, Francis Fuller, Bob Wickett, Jim Abbott, Ronnie Waddell, John Dall, and Bill Folsom (coach).

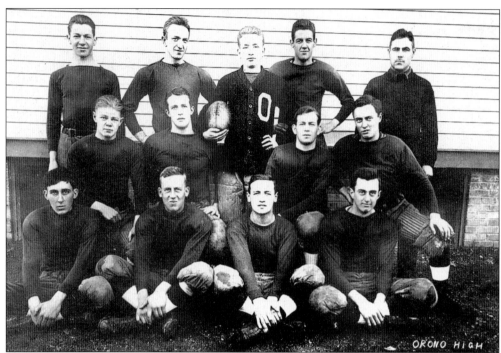

In these two photographs, members of the 1914 Orono High football squad line up outside the Birch Street School (above) and at Oriole Field (below). The players from the above photograph are identified, from left to right, as follows: (front row) Carl Tenney, Pat Dorr, Edmund LaPointe, and Raymond Perry; (middle row) Wilbur Park, Walkie White, "Tige" Cowin, and "Gid" Eddie; (back row) Pat Guggin, Eddie Peters, Bertand MacKenzie, Tank Betts, and "Buck" Earswell (a college student). Both Park and Tenney were associated with well-known businesses in town.

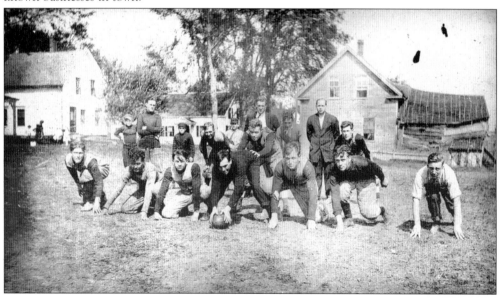

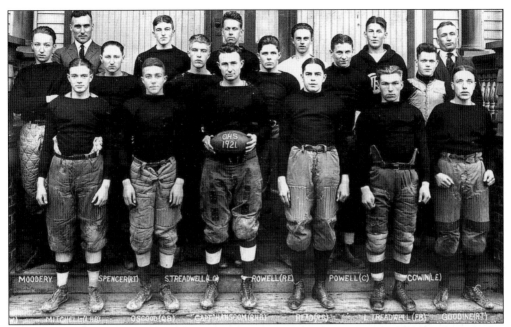

In seven games, opponents only managed to score a total of 18 points off the undefeated football team of 1921, seen here posing on the steps of the high school on Main Street. Members of the team are, from left to right, as follows: (front row) ? Mitchell, ? Osgood, ? Hanscom, ? Read, L. Treadwell, and ? Goodine; (middle row) ? Moodery, ? Spencer, S. Treadwell, ? Rowell, ? Powell, and ? Cowin; (back row) ? Thurston (principal), ? Wing, ? Plourde, ? Barry, ? Ernest, and ? MacKenzie (coach).

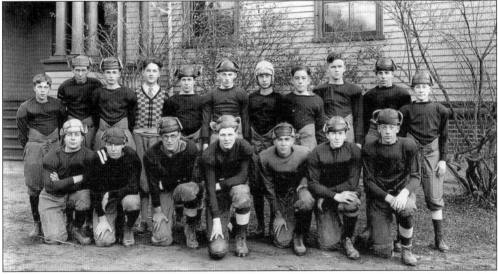

The members of the 1927 football team pose outside the high school. They are, from left to right, as follows: (front row) "Fish" Wilson, Raymond Smith, Stuart Hodgman, Henry Marcho, John Small, Charles "Zeke" Webber, and Wilmont Carruthers; (back row) Howard Myers, Gene Littlefield, Ken Parsons, Stewart Mosher, Carl "Pat" Farnsworth, Roland Page, Harry Day, Llewellyn Spencer, ? Glover, unidentified, and Bruce Ashworth. Orono residents know Carl Farnsworth as the founder of Farnsworth's Café and Pat's Pizza.

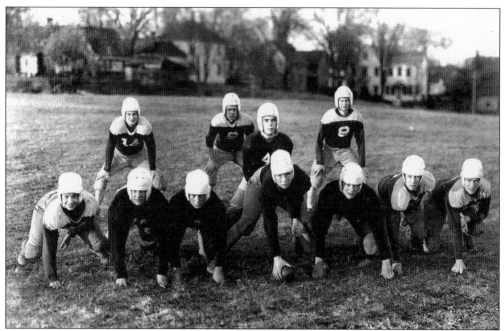

In 1944, Orono High School had enough players out for football to have a second string. They are, from left to right, as follows: (front row) John Perkins, John Needham, Alan Plaisted, Joseph Haverlock, Eugene Hentz, John Littlefield, and Lawrence Deveau; (back row) Lawrence Redmond, Paul Burruby, Thomas Hashey, and Jesse Wilson. According to some players seen here, those were lean years for Orono because most of their bigger players were off to war.

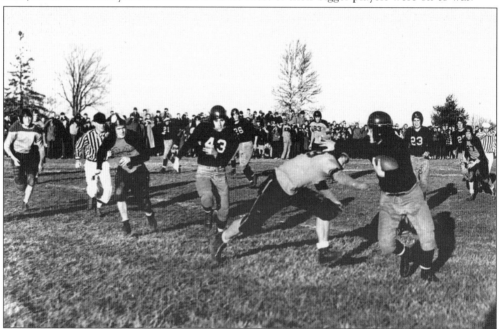

The big boys are back and the action is coming right at the viewer in this scene from a 1946 game against John Bapst High School. An unidentified Orono runner tries to stiff-arm his way to some extra yards, as Francis Proulx (43), Ronald Tibbetts (26), and Edward Wilson (23) look on.

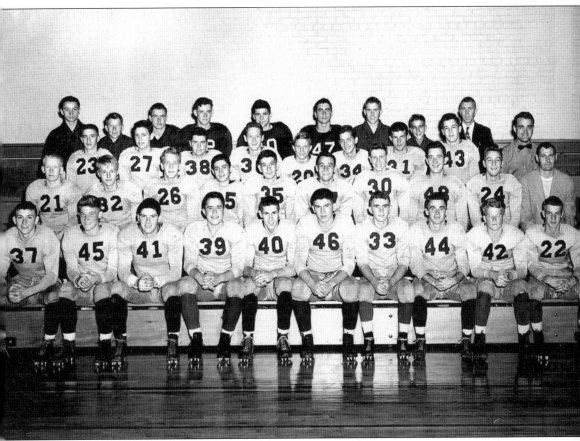

Seen are the members of the 1952 state championship Orono High School football team. They are, from left to right, as follows: (first row) William "Bud" Gott, John "Jack" Biscoe, John "Jack" Pelletier, William "Colonel" Beebe, Rupert "Rupe" Lyon, Lynwood "Lennie" Hashey, Robert "Bob" Deering, Bernard "Bernie" Corneil, Mark Biscoe, and Ross S. "Coo's" Cota; (second row) Richard "Dick" Jenness, Frank "Crazy Legs" Beyer, Frank Simpson, Gary Goodin, James "Jim" Treadwell, John Dall, William "Bill" Bushing, Richard "Isaac" Witter, Arthur "Chink Jr." Parlin, and coach Robert "Bob" Emerson; (third row) Howard "Howie" Beaulieu, Roger Clapp, Raymond Baker, Frank "Putt" Tenney, Richard Brockway, Amasa Sherman, Arnie Doyon, Arthur "Artie" Treadwell, and assistant coach Roger Bryant; (fourth row) manager Ross "Curly" Wyman, manager James "Jim" Goode, Irvin Morrison, Ronald "Earl" LeClair, Donald "Dubber" Deveau, Dudley "Kappa" LaPointe, manager David "Ace" Adams, manager Paul Clancy, and coach Bernard "Barnie" Deering.

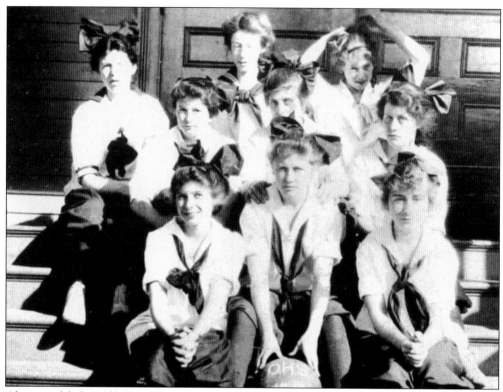

Above and below, the members of the 1915–1916 girls' high school basketball championship team try two different poses on the steps of the old high school on Main Street. Only three players from the above photograph have been identified: Rose King (holding the ball), coach Jane Carpenter (second row, third from the left), and Elizabeth Ring (third row, second from the left).

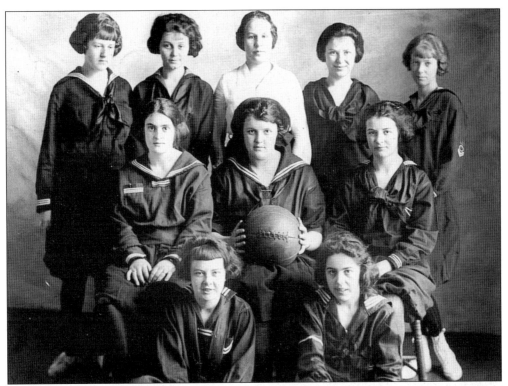

Big black bows were out and the sailor motif was in for this unidentified team photograph of the Orono High School girls' basketball team of the early 1920s.

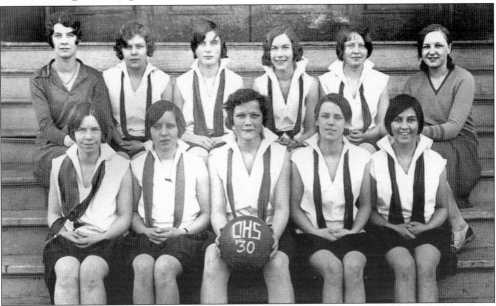

Seen here are members of the 1930 girls' basketball team. They are, from left to right, as follows: (front row) Lynette Spencer, June King, captain Elizabeth Myers, unidentified, and Matina Currier; (back row) coach Eileen Cassidy, Mildred Burpee, Anne Waters, Ruth Barrows, Helen O'Leary, and manager Carrie Flynn.

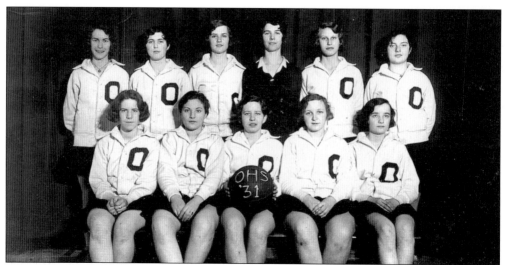

As with the boys' teams, the uniform changes keep coming, as illustrated in this photograph of the 1931 girls' basketball team. Seen here are, from left to right, the following: (front row) Lynette Spencer, Bertha Pepper, June King, Carrie Flynn, and Ruth Perry; (back row) Ruth Barrows, Annie Waters, Edith Gardner, coach Eileen Cassidy, Louise Gibbs, and Maybelle Ashworth.

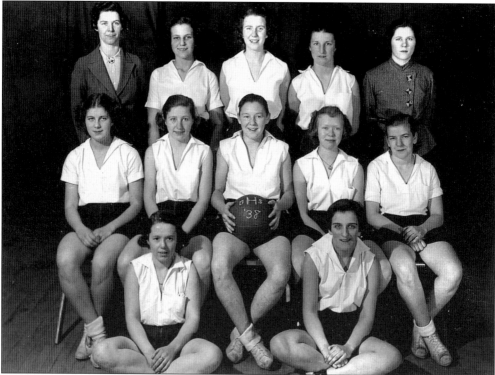

Here is the girls' high school team from 1938. Members are, from left to right, as follows: (front row) Joan Cota, guard; and Helen Myers, guard; (middle row) Virginia King, guard; Helen Deering, guard; Mary Butler, forward; Barbara Brice, forward; and Lucille Spencer, forward; (back row) coach Eileen Cassidy, Lillian Silver, forward; Ruth Loring, guard; Janet Keene, forward; and Kay McCourt, manager.

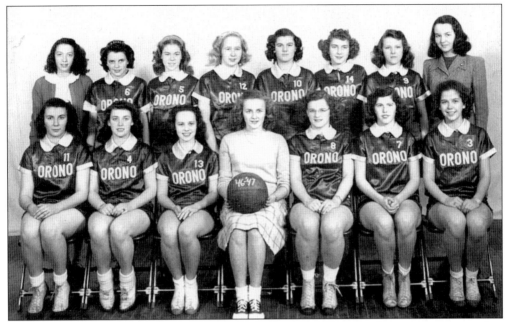

Skipping into the next decade, the members of the 1946–1947 team demonstrate yet another uniform change. They are, from left to right, as follows: (front row) Charlotte Naumilket, Grace Murray, Lois Ann Fox, Gladys Naumilket (manager), Patricia Hachey, Edith Curtis, and Mary Snyder; (back row) Gertrude Wyman, Mabel Powers, Phylis Noyes, Valdine Chalmers, Joyce Hollands, Laura King, Geraldine Chadbourne, and Jean Dolloff.

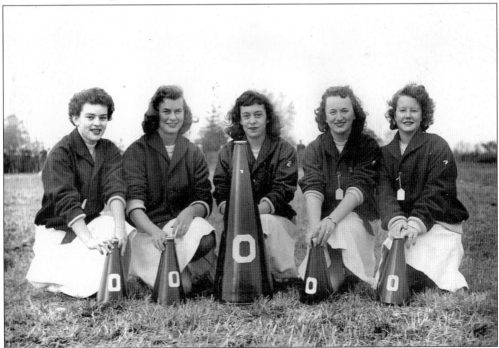

The cheerleading squad for Orono High School in 1944 is pictured here. Members of the squad are, from left to right, Anna Cowin, Grace Murray, Gloria Fisher, Mary Virgie, and Ruth Small.

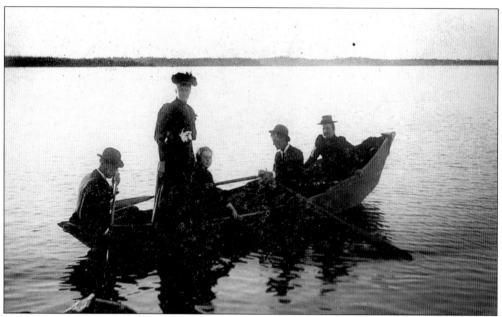

As illustrated in this 1895 photograph taken at Perk-O-Rock, leisure-time activities at Pushaw Lake were an important part of life during the summer in Orono, when the town seemed to quiet down during July and August. Local residents fished and boated, some of them being well known for "displaying the boating skills of submariners," according to local newspapers.

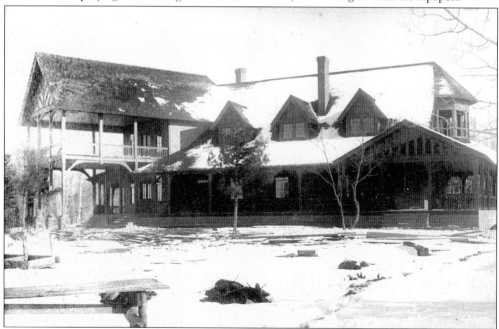

The Niben Club, pictured here, was located on the shore of Pushaw Lake in Orono. Built in the late 1800s, it was a recreational and social club created by prominent residents of Bangor. During the bicycle craze of the 1890s, an eight-mile bike path followed the roadbed of the old Veazie Railroad and brought members there to swim and canoe in the summer. The club burned in 1924.

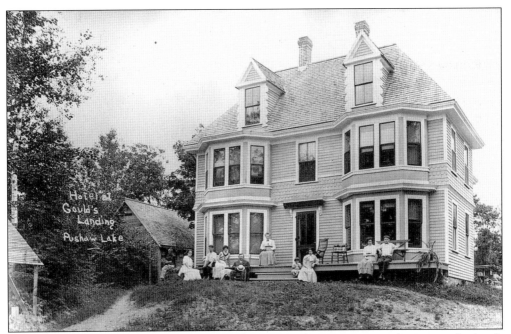

The hotel at Gould's Landing on Pushaw Lake was another summertime destination for locals and tourists alike *c.* 1900. Then, as now, any number of camps (which are distinctly different from the cottages lining the coast around Bar Harbor and Mount Desert Island) ringed Pushaw for use during the warm months.

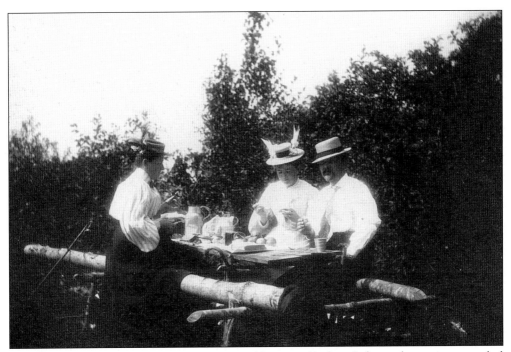

Unidentified picnickers rough it on a rustic table out at Pushaw Lake as they enjoy a meal al fresco *c.* 1900.

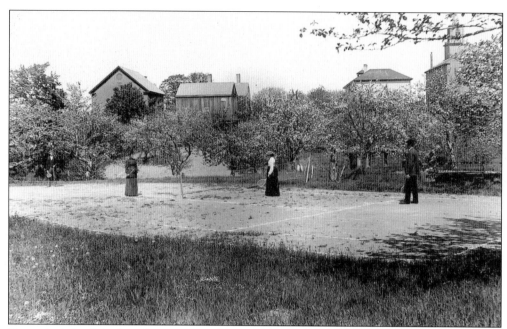

Not to be left off the list of summertime leisure activities is a game or two of lawn tennis at the Buffam house on Bennoch Street, as illustrated in this photograph from the 1890s. The Congregationalist church is visible in the upper right-hand corner.

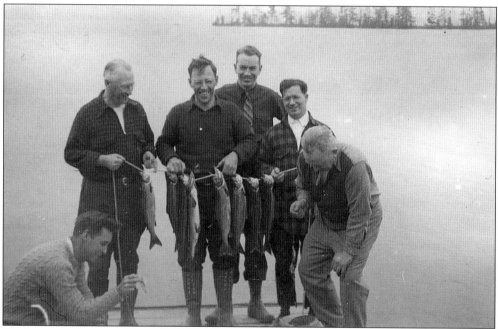

This picture illustrates the ones that did not get away during one of the many fishing trips Orono residents used to, and still, take to Pushaw Lake. The local weekly newspaper was often filled with detailed accounts of trips by various well-known citizens from Orono, as well as the usual fishing stories.

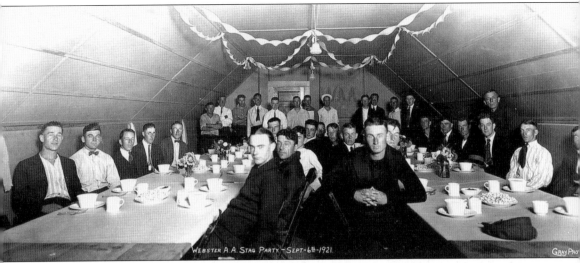

Like the Tough End, the Webster side had its own sports clubs, as this photograph from 1921 illustrates. Members of the Webster Athletic Association include, from front to back, the following: (left side of table at the left) Arthur Hashey, Nicholas Hachey, Linwood Snyder, Fred Babbin, and Winfield Spencer; (right side of table at the left) Lawrence Baker, Francis X. Hachey, two unidentified men, and Raymond Baker; (left side of table at the right) Winston Page, Bill Hanscomb, two unidentified men, and William Spencer; (right side of table at the right) unidentified, "Wint" Page, Tom McGinn, Andy Wing (standing), C. Byron "Hi" Smith, and two unidentified men. Standing at the rear of the tent, on the far left, is Cyl Hachey. The rest of the men who are standing are unidentified. In 1920, much ado was made in the local paper when one of the Baker boys left the Webster Athletic Association training table to join the Orono Orioles baseball team, which was mostly a Tough End conglomeration.

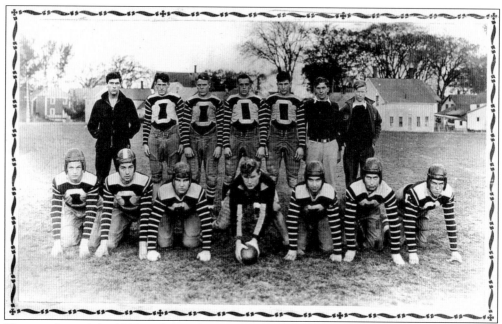

The members of the 1932 undefeated, unscored upon Orono High School football champion team are, from left to right, as follows: (front row) Kenneth King, Morley Myers, Alex Silver, captain Fred King, C. Kenneth Deveau, Harold Deveau, and Len Page; (back row) coach Charles Lampson, Bernie Sullivan, Ed O'Leary, Bud Baker, Ralph Viola, assistant coach Howard Myers, and manager Charles King.

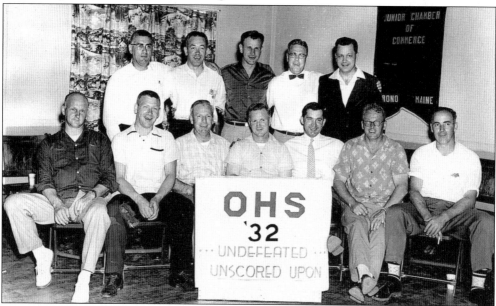

At a 1956 reunion hosted by the Orono Chamber of Commerce, the famous high school team reprises their championship lineup. Seen here are, from left to right, the following: (front row) Kenneth "Perk" King, John Myers, Fred Spencer, Fred "Red" King, Ken Deveau, Everett "Bingo" Sullivan, and Morley "Heifer" Myers; (back row) coach Charlie Lampson, Freddie Burpee, Ralph Viola, Edward O'Leary, and Glen Waddell.

# Seven

# NOW SHOWING:
# THE NATIONALLY KNOWN
# KID'S BAND OF ORONO

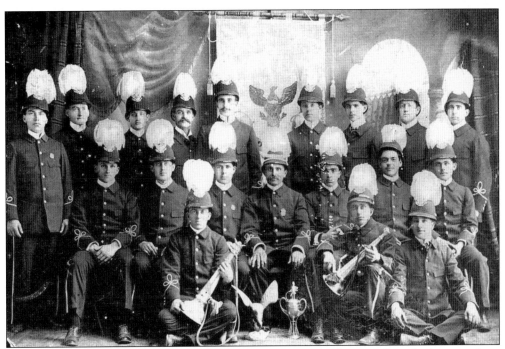

Orono's Eagle Hose Company lines up c. 1885 for a group photograph with their speaking trumpets, eagle emblem, and world championship trophy. The shapes above their heads are not plumes, but erasure marks. At this time, Orono had three companies: the Eagle, located in the town hall; the Monitor, located on the Webster side, and the Tiger, stationed in the Basin.

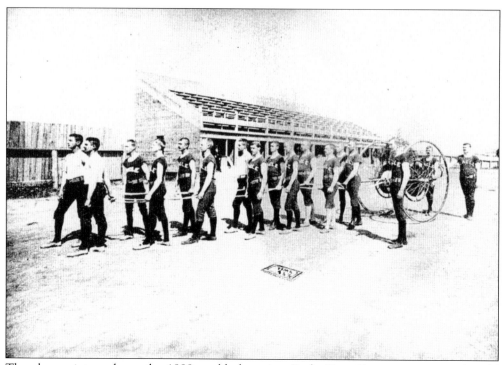

The above picture shows the 1888 world champion Eagle Hose Company team at the old Orono race track, which was located where Grove Street now runs off Park Avenue (hence, the name of the street). This team pulled their hand-drawn hose cart 1,300 feet in a mere 45 and 1/4 seconds. The photograph below shows the Eagle hose cart in a noncompetitive setting, namely the dirt roads of Orono c. 1900. Arthur Smith is holding the ax. Originally, the Eagle was housed in the basement of the town hall.

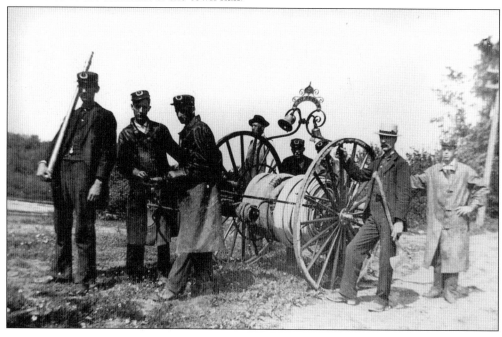

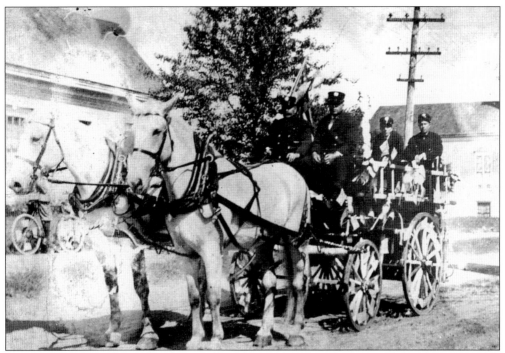

The Tiger appears to be decked-out for the Fourth of July in this *c.* 1918 photograph. By this point in time, Orono's fire department was centrally located on Bennoch Street. Charles and Frank Cowan are seated in the front seat, with Charlie Burribye and Everett Spencer taking up positions on the back of the wagon. In the background is the Becky Merriman homestead, which occupied the site of the present post office.

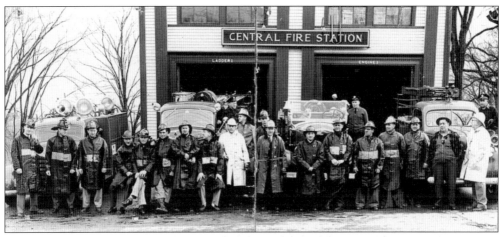

Members of the Orono Fire Department line up in front of the Central Fire Station *c.* 1949. They are, from left to right, as follows: (front row) Ray Leclair, Red Fortier, C. Sullivan, Frank Flower, A. Dall, Laurence Dall, Jim Nadeau, B. Cote, John Myers, Healy Dall, Tug Hogan, Carl Myers, E. Lounsbury, Dagwood LeClair, V. Myer, Frank Clemont, H. Burton, and Chief Ed Peters; (back row) B. Sullivan, K. King, L. Lounsbury, G. Jedrie, and Jim Campbell.

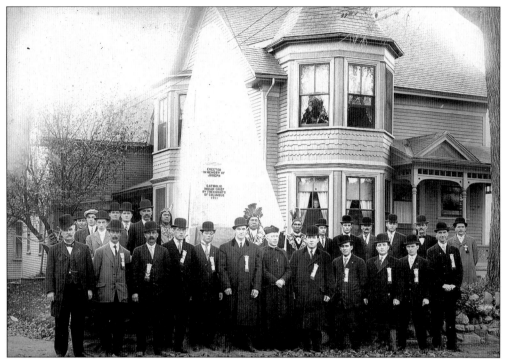

Local members of the Knights of Columbus and Penobscot Indians pose at the dedication of a monument memorializing Chief Joseph Orono, for whom the town was named. Dedicated on Columbus Day 1911, the original monument was toppled by a delivery truck in 1988. A replacement was created and placed in front of the Main View Apartments, once the home of St. Mary's School.

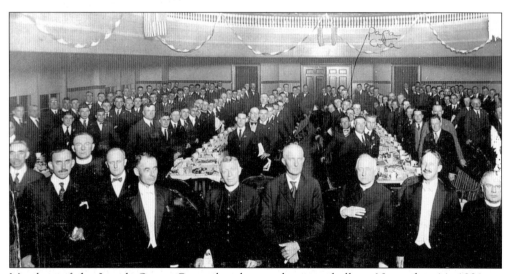

Members of the Joseph Orono Council gather at the town hall on November 14, 1921, to celebrate the Silver Jubilee of the local Knights of Columbus council, which was formed in May 1886. Joseph Cota, long known as Orono's genial tax collector, is on the left-hand side of the second table from the left, third from the front.

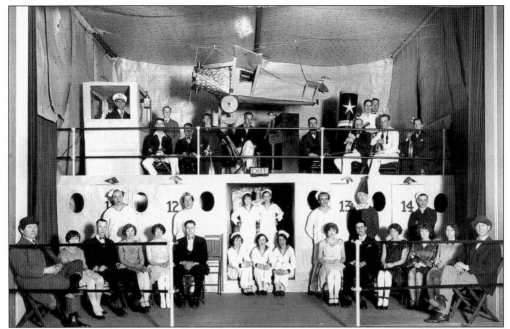

The Knights of Columbus regularly put on shows at the town hall to benefit St. Mary's Church. These photographs show the casts for two of the shows. The above photograph seems to date from the late 1920s, with the *Spirit of St. Louis* replica hanging above the ship. Local musicians and thespians joined these casts to make it a community-wide production.

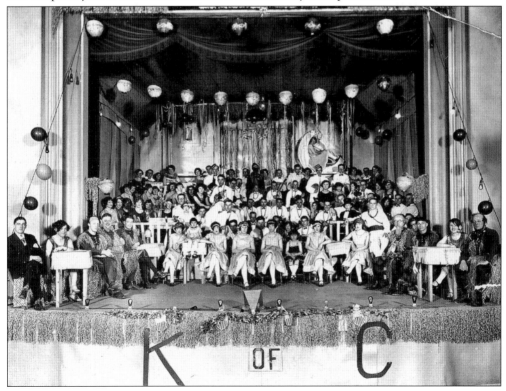

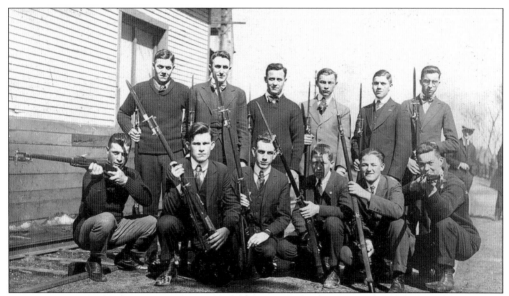

Here, a squad of Orono's veterans from World War I poses in front of the Maine Central Railroad shed at the main station on Middle Street. Harry Burton is at the far right in the front row, George Ambrose is second from the left in the back row, and George Gonyar is fourth from the left in the back row.

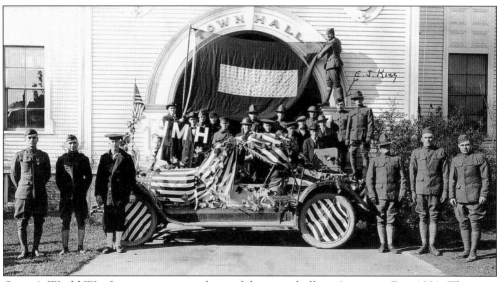

Orono's World War I veterans pose in front of the town hall on Armistice Day 1921. They are, from left to right, as follows: (front row) Fred Prue, Bert MacKenzie, Healy Dall, Seldon Page, Harry Tozier, and unidentified; (back row) unidentified, Frank Ambrose, Edward Peters, three unidentified men, Kenneth Noyes (in the soft army hat), three unidentified men, Mickey King (in the sport cap), three unidentified men, George Campbell, and ? Hashey (holding the top corner of the flag).

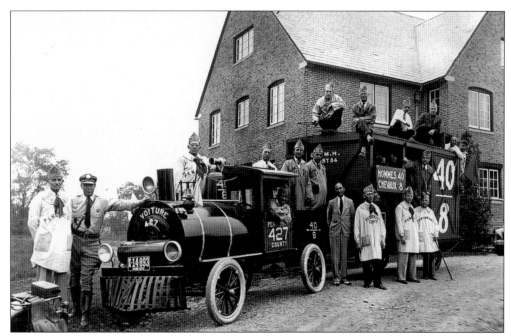

American Legion members from Orono pose in, on, and around a mock-up of the narrow-gauge trains that were used to transport troops from Paris to the front lines in World War I. The boxcars could carry 40 men or 8 horses, hence the name "40 and 8." After the war, the French government sent over souvenir boxcars for each state. Maine's boxcar resides at the train museum in Boothbay Harbor.

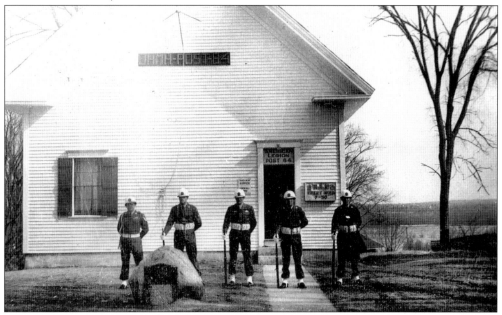

Orono American Legion post members Tom Hashey, "Wawa" Dall, Alfred Dall, Philip Hashey, and Joe Haverlock comprise an honor guard in 1953. At that time, the Legion Hall was located in the building that once housed Primary No. 2. In the background are the Basin and the Penobscot River.

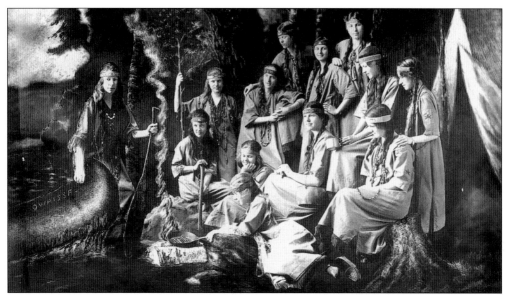

In this 1917 photograph, the Campfire Girls of Orono appear ready to break into a song. They are, from left to right, as follows: (first row) Helen Palmer; (second row) Geneva Carpenter, Alice Ames, Barbara Munson, Elizabeth Ring, and Lillian Dunn; (third row) Pearl Palmer, Helen McPheters, Marjorie Brooks, Eleanor Whiteside, and Madeline Brown; (fourth row) Frances Whiteside and Helen Hathorne.

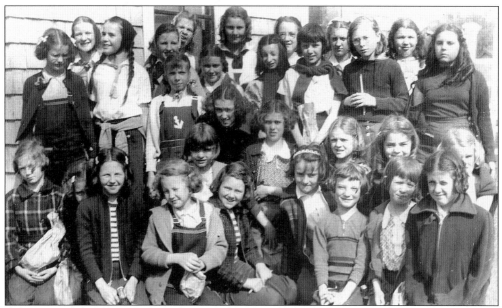

Here is Mildred Wallace's Girl Scout troop from 1938. Members are, from left to right, as follows: (first row) Peggy Sutton, unidentified, Mary Luro, Ruth Small, Janet Redmond, and four unidentified scouts; (second row) unidentified, Jacky Clancy, Anna Cowin, unidentified, and Helen Cowin; (third row) Lois Small, Harriet Steinmetz, Lorraine Littlefield, Mary Weymouth, unidentified, Mary Ann Hillson, Marjorie Merchant, Mary Molloy, Thelma Crossland, and Dorothy Jordan; (fourth row) unidentified, Mary Dirks, unidentified, Verday Thompson, Janice Crane, and unidentified.

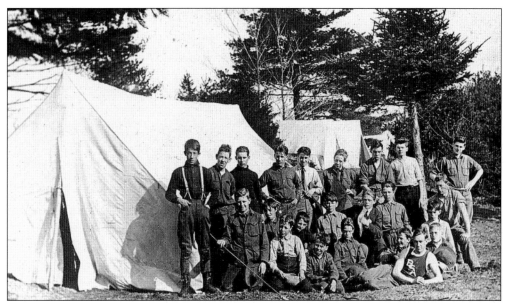

Taken in May 1914, this photograph shows Orono Boy Scouts at their first camp. They are, from left to right, as follows: (first row) Sam Hitching; (second row) Roger Goodine, Donald Powell, Merle Lounsberry, Russel Fogg, and Earl MacKenzie; (third row) Davis Chase, Arthur Lauren, Donald Friday, Ernest Ring, Clarence Reed, Raymond Rees, Wendell Cunningham, and ? Brown; (fourth row) Stanley Weiss, Richard Hart, Lawrence Deveau, Cory Gay, Edgar Smith, Fred Whiteside, Douglas Beal, Crosby Redeau, and William Spencer.

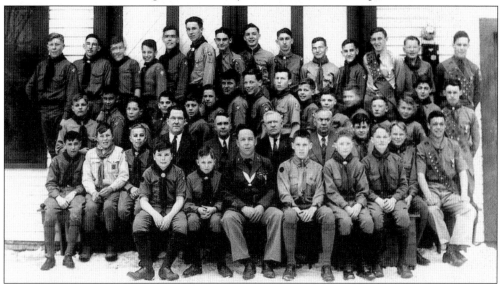

A larger troop went to camp in 1941. Seen here are, from left to right, the following: (first row) Weymouth, Beedy, Sweatt (scoutmaster), Hall, Cloke, and Folsom; (second row) Dall, Henry, Gonyar, Evans, H. Leavitt, Davee, Beale, R. Noyes, Murray, and Sweatt; (third row) Oliver, Brideau, Fielder, McGinn, Gardner, Perkins, Jones, E. Snyder, VanDine, R. Snyder, Lathrop, Levinson, Plummer, Sturgeon, A. Noyes, and Porter; (fourth row) Wilson, R. Vasquez, Page, Wyman, Treat, Steinmetz, W. Evans Jr., Jenkins, W. Evans, Jones, W. Vazquez, Stewart, Turner, and L. Leavitt.

This postcard from the late 1920s shows the members of the Orono Harmonica Band performing at the town hall. Drum major Robert Brautlecht leads the cast of 200 in such favorites as "Glow Worm," "Red Mill," "Rose Maiden," and "Hold Me." Local music teacher Belle A. Virgie directed the band, and Eileen Cassidy, a member of the physical education department at the university, helped with the costumes.

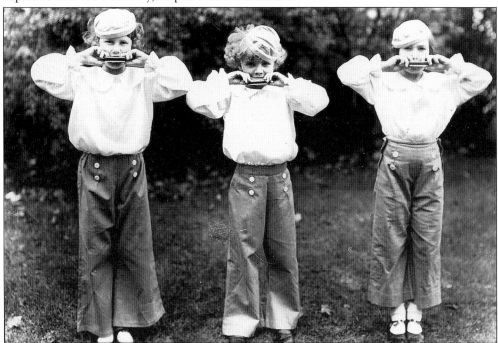

Phyllis Pratt, Jean Wallace, and Lois Ann Small are pictured here as the performers for "War Song" and "Two Part Song." Their uniforms consisted of blue cambric trousers (for both boys and girls), white satin blouses, and blue and white bellboy caps. Along with small group performances and solos by the harmonica players, the program also included vocal solos of "Home on the Range" and cowboy dances.

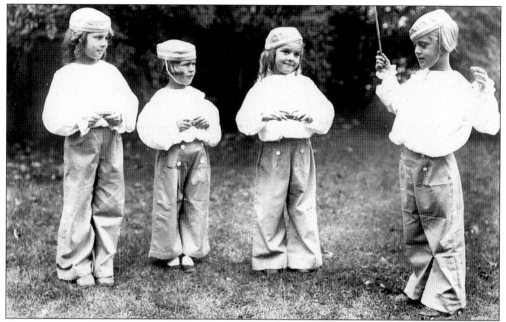

Bernice Goulet, Helen Gallant (perhaps the youngest band member at age four), first-grade soloist Anna Cowin, and section leader Helen Cowin were the performers on "Twinkie." In the early 1930s, Belle Virgie's Orono Harmonica Band was captured in a Paramount newsreel, showcasing the town's talents nationwide. This newsreel was brought to Orono's very own Strand Theater in December of that year for what was advertised as a "Special Extraordinary Attraction."

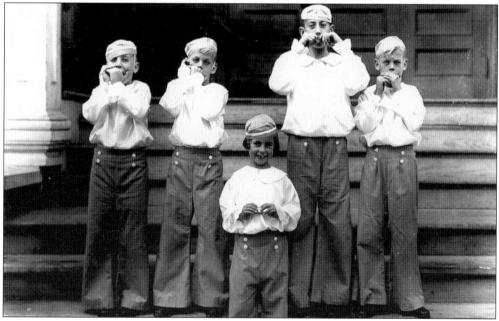

Harmonicas at the ready, Lawrence Beaulieu, Harold Beaulieu, Ruth Beaulieu, Bernard Peters, and Bobby Beaulieu pose in uniform on the town hall steps. Bernard took a solo in "Flying Trapeze," and at age seven, Ruth soloed on "The Big Bad Wolf." In 1936, Belle Virgie directed a production of *Peter Rabbit* that involved over 126 students.

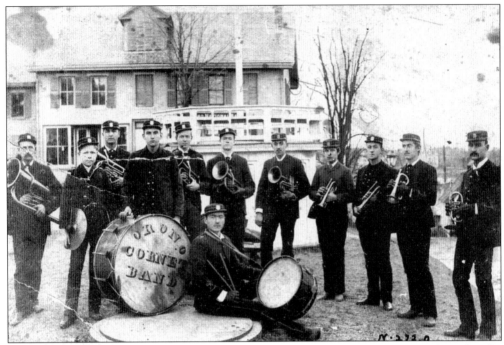

These unidentified members of the Orono Cornet Band are about to take the bandstand in the square. Conspicuously absent is the Civil War statue that gave the square its name, indicating that this photograph was taken prior to 1892, which jibes well with a cornet band bill from the 1880s that is in the possession of the Orono Historical Society.

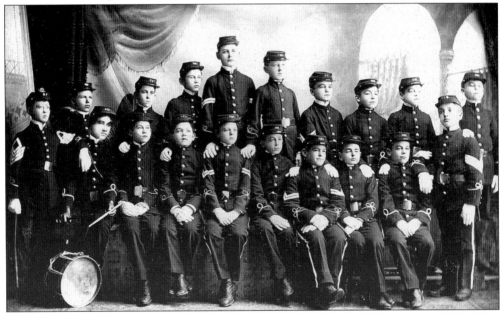

Unidentified members of the Orono Cadet Band pose in the late 1800s or early 1900s. This band was organized and directed by Fr. John Harrington of St. Mary's Church and is one of many bands from Orono's past. Orono has rich musical heritage, as residents have been involved with music both during and after their school years.

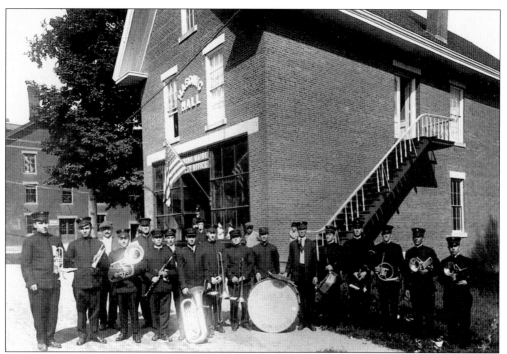

Members of Orono's Citizen's Band stand in front of the post office *c.* 1916. F. P. Tenney's songbook contains the hand-written scores for over 40 songs, waltzes, polkas, and two-steps, including such favorites as "Yankee Doodle," "John Brown's Body," "Rhubarb Pie," "Mocking Bird," and "Take Me Back Home to Mother."

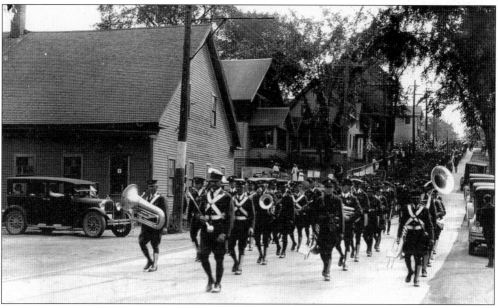

This *c.* 1920 photograph shows a marching band reaching the foot of Ferry Hill. Note the steepness of the hill and the overarching elm trees. Shaw and Tenney's paddle and oar factory is on the left. The houses between it and the post office at the top of the hill are long gone, as is the street parking in the area.

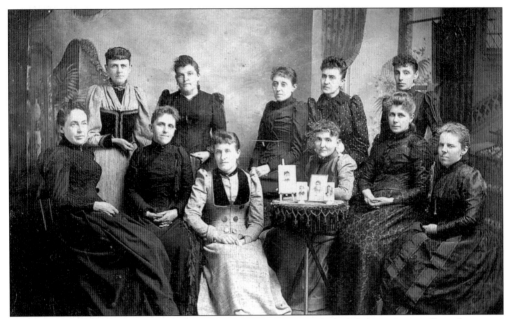

In the late 1800s, the ladies of Orono's Literary Society included these women. Seen here are, from left to right, the following: (front row) ? Colburn (Fernald), Kit Mayo, Annie Lunt, Hannah Rogers, A. M. Hamlin, and unidentified; (back row) ? Jordan, ? Gowell, unidentified, S. Frost, and unidentified. Note the miniature photographs of the society members who could not be present for the photograph. One of them is probably Isabel Ring Dunn, the mother of Barbara Dunn Hitchner.

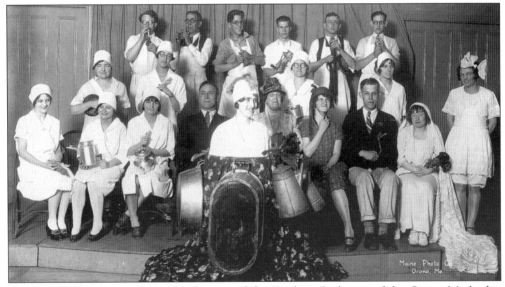

Helen Park (front center) was the director of the Kitchen Orchestra of the Orono Methodist Church Choir. She was backed up by, from left to right, the following: (front row) Della Rich, unidentified, Viola Morrison, Robert Myers, ? Gibbs, unidentified, Harold Inman (groom), Alice Plummer (bride), and Mary Round; (middle row) Inez Myers, Susan Day, unidentified, and Alice Morrison. In the back row are John Myers and Dudley Foley, but their locations in the row are unknown.

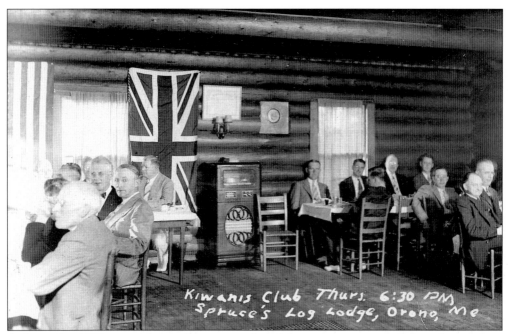

Perhaps this 1937 postcard served as a reminder of the meeting time and place for members of Orono's Kiwanis Club, which has long been an active and important organization in the community.

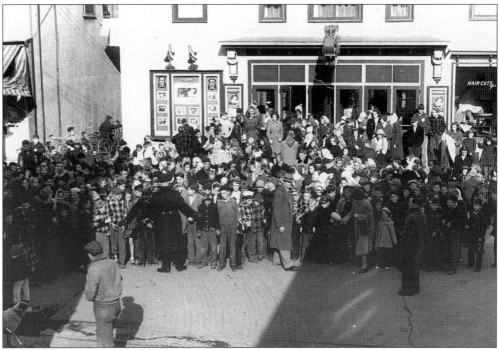

Local tots of all ages appear to be anxiously awaiting the arrival of St. Nick in this photograph of the Kiwanis Christmas party from 1939. In the background is the Strand Theater, which occupied the site of the current Orono Pharmacy.

## *An Invitation to...*

# The Orono Sesquicentennial

JUNE 14, 1956 — Banquet . . . Pageant

JUNE 15 — Historical Exhibits . . Tours . . Children's Program
. . Old Time Sports Events . . Pageant . . Dance

JUNE 16 — Tours . . Exhibits . . River Driver's Supper . . Parade
. . Pageant

SPECIAL FEATURE — A dramatic pageant portraying the
history of Orono

We hope you will come

In 1956, members of the Orono Sesquicentennial Committee issued the above invitation to the three-day celebration marking the 150th anniversary of the town's founding in the front room of Col. David Reed's house. The committee was cochaired by Gerald H. Grady and Barbara Dunn Hitchner, pictured below with the birthday cake that was presented at the banquet on the first night of the celebration. Other events included historical discussions led by Hitchner, tours of the town's finest historic homes, a concert by the high school band, and demonstrations by firemen and old-time logrollers.

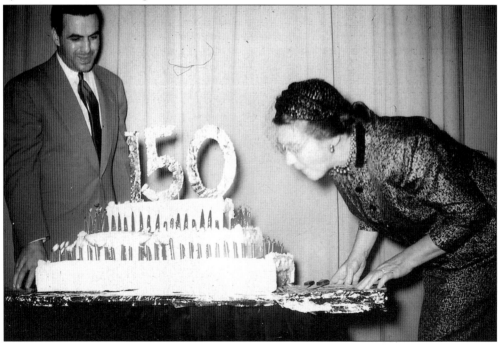

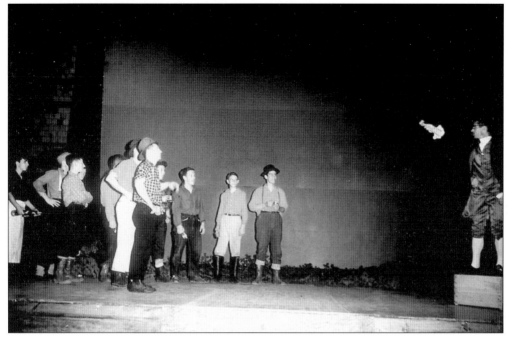

In Hershel Bricker's pageant, "This Is Your Town," 150 years of Orono history were presented. Depicted above is the infamous 1836 auction conducted by the Bangor-Lower Stillwater Mill Company to sell lots on and around Ayers Island. The economy was already showing signs of the collapse that followed in 1837, but a steady flow of champagne for the bidders helped nearly $500,000 trade hands that day. Below, from left to right, John Pettigrew Jr., Phyllis Stewart, Ronnie Parent, Ruth Kimball, John Veno, and Marjorie Small honor Orono's World War II veterans during the "Soldier Business" portion of the pageant, which had a cast of over 200 residents.

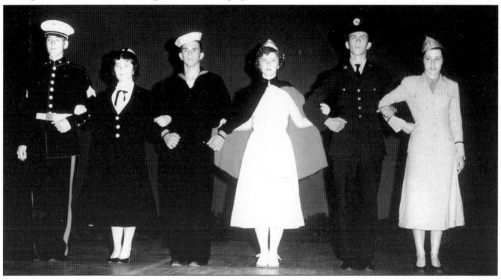

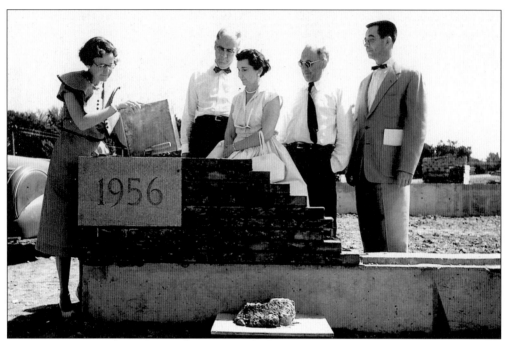

Above, Mary Louise Giddings places a time capsule in the cornerstone of Asa Adams Elementary School as Dr. Asa Adams, Austice Jardine, Alonzo J. Harrison, and Joseph Devitt look on. Below, Orono's youngsters of 50 years ago gather for a bicycle parade that will take them through Monument Square and on into the future. Now, 50 years later, Orono is approaching its bicentennial, marking 200 years of history. The lumber and paper mills are a thing of the past, along with any number of landmarks featured in this book, but the town's rich history will no doubt serve it well as its citizens carry Orono forward into its third century of existence.

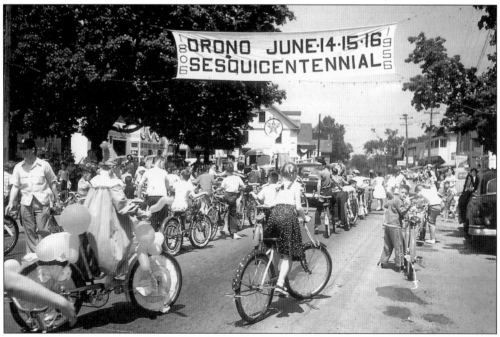